ACADIAN
Pictorial Cookbook

Photographs by Wayne Barrett

Introduction by Barbara LeBlanc

NIMBUS
PUBLISHING LTD

Nimbus Publishing Limited
P.O. Box 9301, Station A
Halifax, Nova Scotia
B3K 5N5

Design: Arthur Carter, Halifax

Recipe credits: *Out of Old Nova Scotia Kitchens*, by Marie Nightingale; *The Apple Connection*, by Beatrice Ross Buszek; New Brunswick Department of Tourism, Recreation & Heritage; New Brunswick Department of Fisheries and Aquaculture; Marg Routledge, Fredericton

Canadian Cataloguing-in-Publication Data

Barrett, Wayne.

Acadian pictorial cookbook

ISBN 0-921054-62-9

1. Cookery, Acadian. 2. Maritime Provinces— Description and travel— 1981— Views.* I. Title.

TX715.6.B37 1991 641.59715 C90-097709-4

Printed and bound in Hong Kong by Everbest Printing Company, Ltd.

Cover: Statue of Évangéline, Grand-Pré National Historic Site, Grand-Pré, N.S.
Title page: Rowboat, Bouctouche, N.B.
Table of Contents: Cap-Egmont, P.E.I.
Back cover: Acadian flag, P.E.I.

Table of Contents

Introduction

By Barbara LeBlanc

Cultural heritage is like a rainbow of interwoven threads consisting of various aspects of daily life, and one of these threads is cuisine. Every ethnic group has its own culinary traditions. The foods of the Acadians reflect a blend of traditional French eating patterns adapted to a foreign land and influenced by contact with Micmac and Malecite peoples.

Most Acadians in the Maritimes are descendants of farmers and labourers who came to the New World from central western France in the mid-seventeenth century. They began a new life in Acadie, where strong family ties and a common religion, language, and ancestral tradition helped to create an independent, cohesive community.

The first group of Acadian settlers landed at LaHave, Nova Scotia, in 1632. In 1636, they moved to Port-Royal, and as the population grew, they began to settle farther up the Annapolis River and, by the end of the century, along the Bay of Fundy. Eventually, a group settled on Prince Edward Island. As a result of the Deportation (1755-1763), these Acadians lost their land and were scattered around the world.

Descendants of the Acadians who resettled in the Maritimes after 1763 can be found today in pockets along parts of the coastlines of Nova Scotia, Prince Edward Island, and New Brunswick. If we flew over these communities, we would soon discover similar eating patterns. Then if we travelled in a time machine and visited Acadian communities of the seventeenth, eighteenth, and nineteenth centuries, we would find foods such as *fricot,* soup, fish, pork, turnip, cabbage, pancakes, apples, bread, butter, and molasses. Taken together, these two magical journeys would reveal that basic Acadian cuisine has not changed much over the centuries. Simplicity is still the main characteristic: one-pot meals such as *fricot,* rappie pie, meat pie, and boiled-ham or salt-cod dinners are nearly as common today as they were years ago.

In the early settlements, Roman Catholic religious restrictions partly dictated food consumption. Acadians abstained from meat for more than 150 days a year, and this, in addition to the abundance of seafood in the Maritimes, offers an explanation for the high consumption of fish, herring and cod in particular. Contact with native peoples also influenced the Acadian diet. Corn, not used in Europe, became an ingredient for dishes such as corn chowder and cornmeal cake. Acadians probably learned hunting techniques from the Indians as well, bringing rabbit, moose, and gamebirds to their tables. There are still many Acadians who enjoy hunting. My father, for example, sets snares, and my mother makes rabbit pies and *fricot* for the Christmas holidays.

Pork was one of the principal meats, along with some beef, mutton, and chicken. The main vegetables included beans, corn, peas, carrots, and onions. The most popular were cabbage and turnip, probably because these vegetables stored well over the winter. The potato was not part of the Acadian diet in the early period. Once it was introduced, however, it became a mainstay.

The Acadian settlers, mostly farmers and fishermen, led a less-sedentary existence than that of their descendants today, and hard physical chores necessitated hearty meals. Breakfast, for example, often consisted of foods such as blood pudding, baked beans, head cheese, or leftovers from the previous evening's meal.

Grist mills supplied whole wheat, oats, buckwheat, and barley. Acadians traded flour made from grains for molasses and sugar from the West Indies. Consequently, molasses became an important ingredient. It is always a treat for me to go home and find freshly baked molasses cake or cookies. Molasses was also a condiment served with pancakes or fresh buttered bread. My family is known as *les mangeurs de mélasse* in the community because we love it so much.

Journals written by visitors to Acadie in the seventeenth and eighteenth centuries refer to various drinks. French wine, home-brewed apple cider, spruce beer, and fir beer, rum from the West Indies, and milk accompanied meals. Milk was also left to thicken and sour, to serve with bread. Historical

documents suggest as well that Acadians were the first to cultivate apple orchards. Cherries, pears, and wild berries such as blueberries and blackberries were served fresh or used to make jams.

Special occasions such as La Toussaint, La Sainte-Catherine, and Mardi Gras were once accompanied by special dishes. La Toussaint, on November 1, is devoted to the memory of the dead, and the day before, it was custom to play tricks on neighbours. One such trick was stealing cabbage from gardens, which was made into soup and enjoyed by everyone on All Hallows Eve. On La Sainte-Catherine, celebrated on November 25, and Mardi Gras, held before the fasting period of Lent, families prepared *la tire* or *tamarin,* a taffy made with molasses or sugar. Egg pancakes for Candlemas, on February 2, and meat pies for Christmas bring back memories of the traditional cuisine.

The recipes in this pictorial cookbook are but a sampling of the rich Acadian heritage in the Maritimes. These are the foods that my family and others have enjoyed for centuries. Take a slice of this culture, and enjoy your journey through Acadian cuisine. *Bon appétit!*

Barbara LeBlanc is the superintendent of the Grand-Pré National Historic Site in Nova Scotia, a memorial to the Acadians deported in 1755.

Régions acadiennes des Maritimes
Acadian Communities of the Maritimes

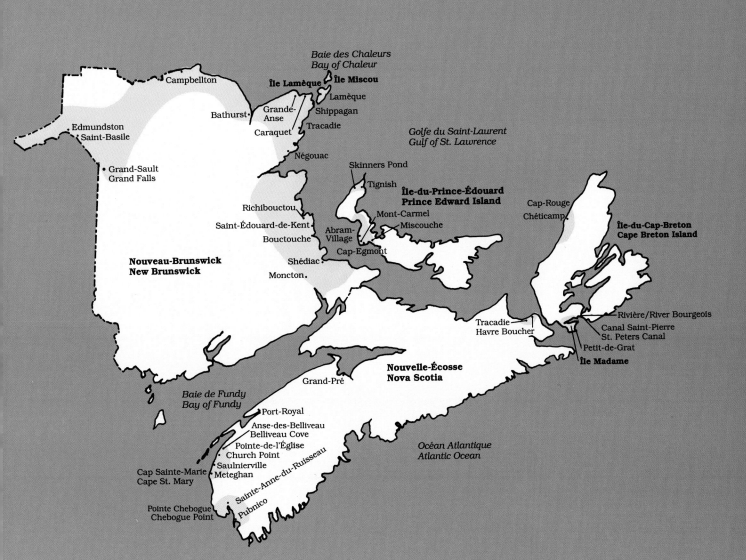

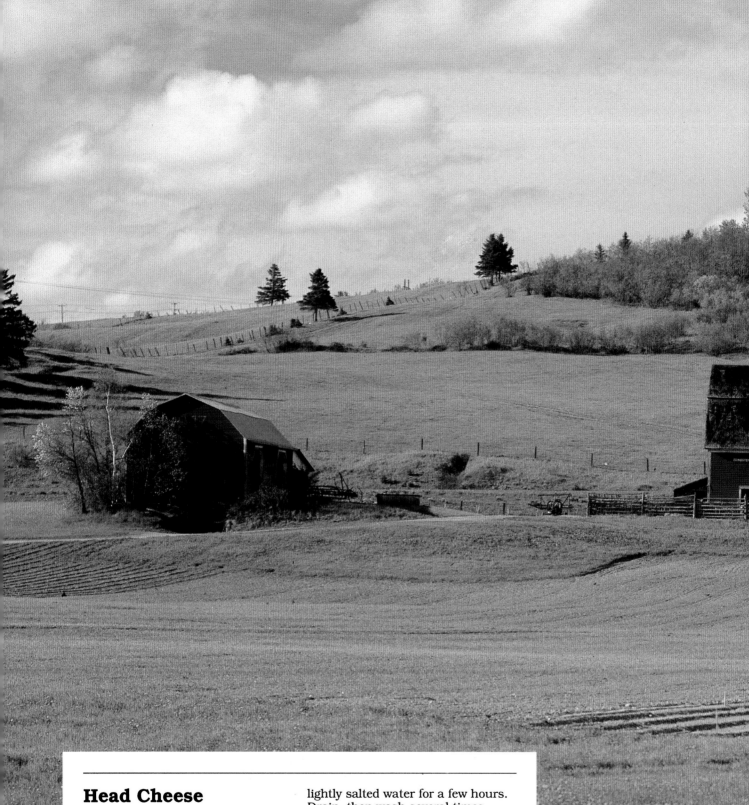

Head Cheese

1 pig's head
Salt
2 large onions, diced
Salt and pepper to taste
1 tsp (5 mL) summer savoury
Ground cloves and cinnamon to taste

Remove undesirable parts of pig's
head. Cut up head and soak in
lightly salted water for a few hours.
Drain, then wash several times.
Combine head, onions, salt, and
pepper. Add enough water just to
cover ingredients. Cook slowly until
meat begins to fall off bones. Strain,
reserving juice. Cut meat into small
pieces. Boil together juice and spices
for 10 minutes. Place meat in
containers and add juice. Let cool
before refrigerating.

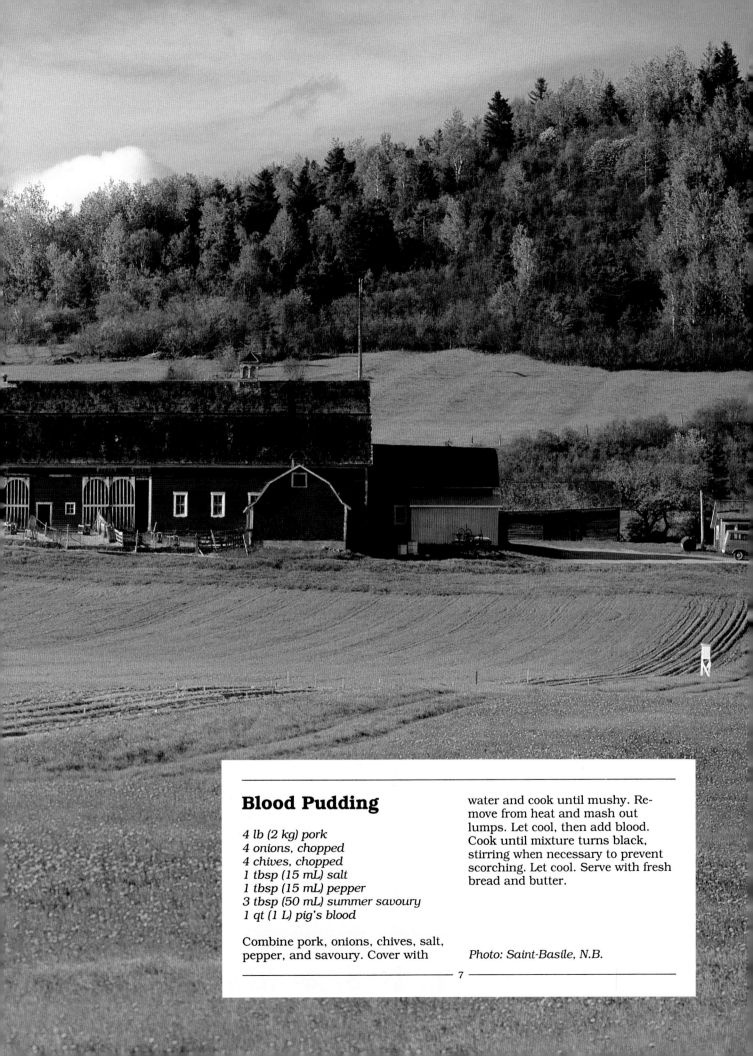

Blood Pudding

4 lb (2 kg) pork
4 onions, chopped
4 chives, chopped
1 tbsp (15 mL) salt
1 tbsp (15 mL) pepper
3 tbsp (50 mL) summer savoury
1 qt (1 L) pig's blood

Combine pork, onions, chives, salt, pepper, and savoury. Cover with water and cook until mushy. Remove from heat and mash out lumps. Let cool, then add blood. Cook until mixture turns black, stirring when necessary to prevent scorching. Let cool. Serve with fresh bread and butter.

Photo: Saint-Basile, N.B.

7

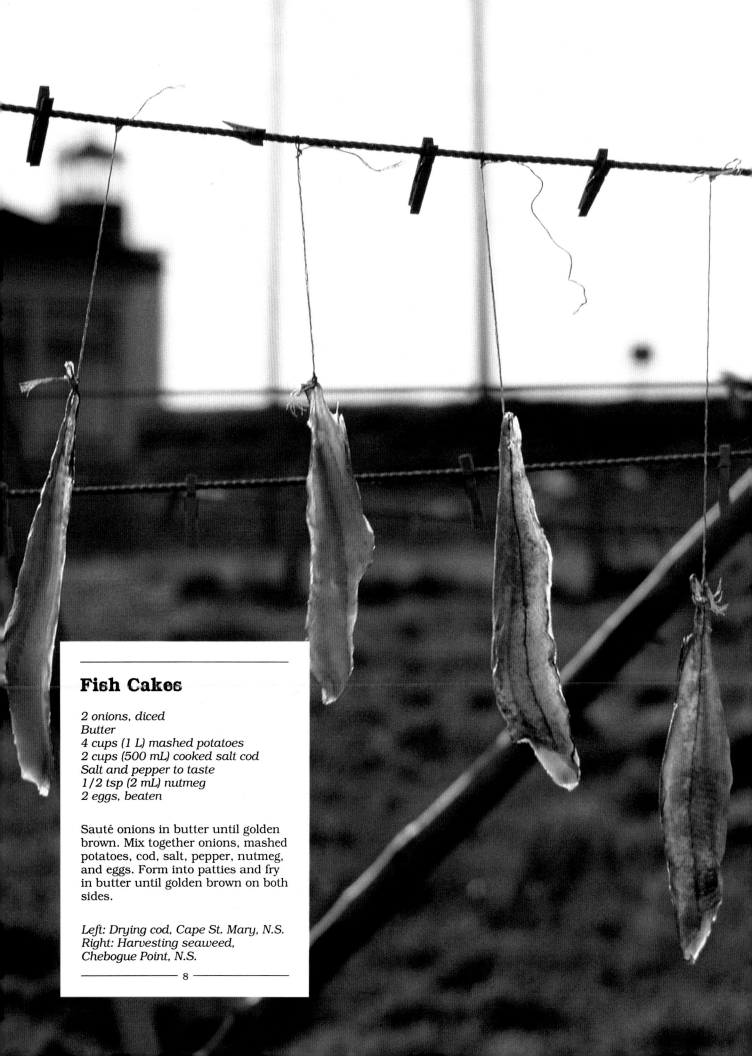

Fish Cakes

2 onions, diced
Butter
4 cups (1 L) mashed potatoes
2 cups (500 mL) cooked salt cod
Salt and pepper to taste
1/2 tsp (2 mL) nutmeg
2 eggs, beaten

Sauté onions in butter until golden
brown. Mix together onions, mashed
potatoes, cod, salt, pepper, nutmeg,
and eggs. Form into patties and fry
in butter until golden brown on both
sides.

Left: Drying cod, Cape St. Mary, N.S.
Right: Harvesting seaweed,
Chebogue Point, N.S.

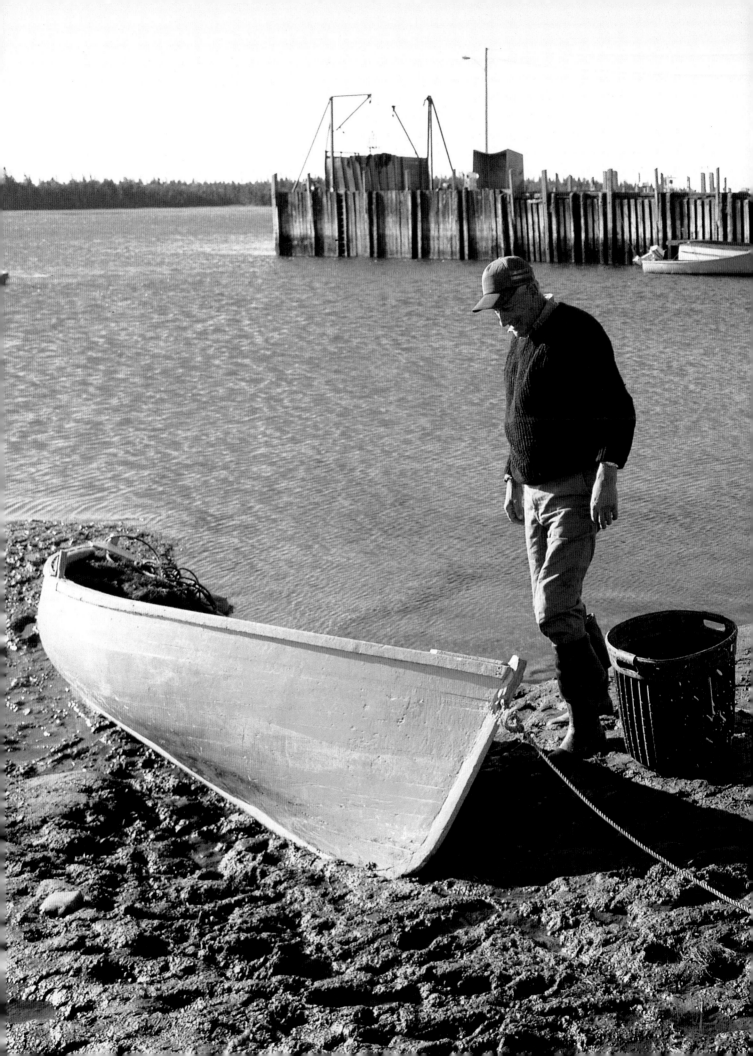

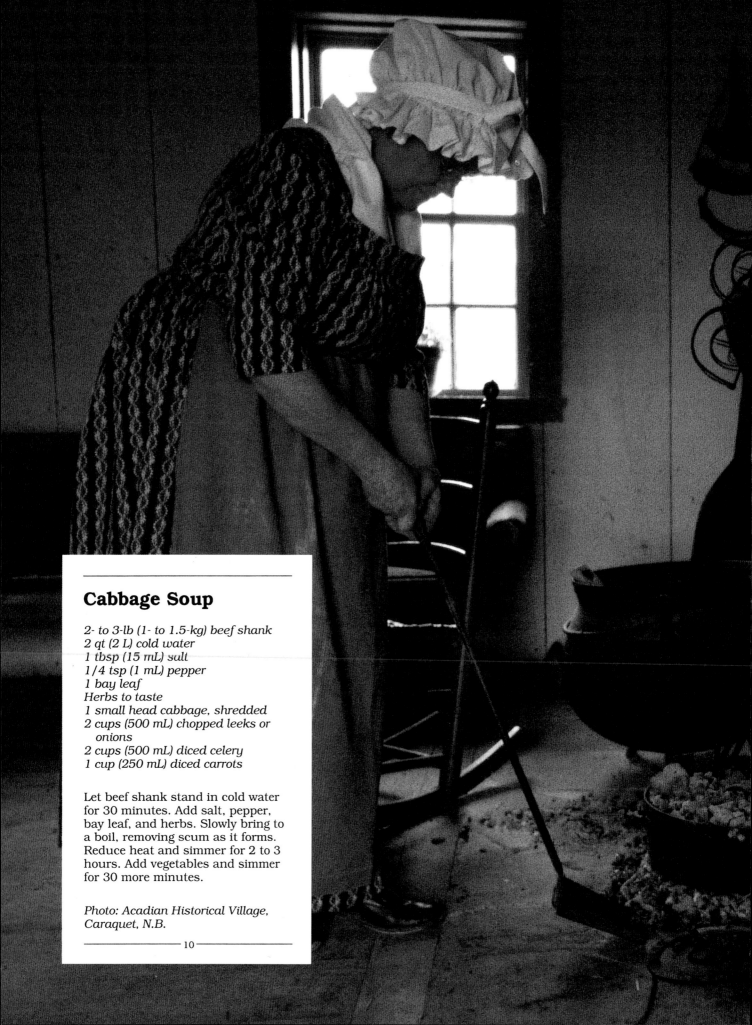

Cabbage Soup

2- to 3-lb (1- to 1.5-kg) beef shank
2 qt (2 L) cold water
1 tbsp (15 mL) salt
1/4 tsp (1 mL) pepper
1 bay leaf
Herbs to taste
1 small head cabbage, shredded
2 cups (500 mL) chopped leeks or
 onions
2 cups (500 mL) diced celery
1 cup (250 mL) diced carrots

Let beef shank stand in cold water
for 30 minutes. Add salt, pepper,
bay leaf, and herbs. Slowly bring to
a boil, removing scum as it forms.
Reduce heat and simmer for 2 to 3
hours. Add vegetables and simmer
for 30 more minutes.

*Photo: Acadian Historical Village,
Caraquet, N.B.*

Split-Pea Soup

2 cups (500 mL) green split peas
1 ham bone
2 qt (2 L) cold water
2 carrots, diced
1 onion, diced
1 celery stalk, diced
Savoury to taste
Cayenne pepper to taste

Soak peas overnight, then drain.
Cover ham bone with cold water and

simmer for 1-1/2 hours. Make sure
lid is tightly closed and do not boil.
Add peas and remaining ingredi-
ents. Simmer for 1 more hour or
until peas are very soft. Remove
ham bone. Rub soup through a
sieve and return to pot. Season
further to taste.

Photo: Bathurst, N.B.

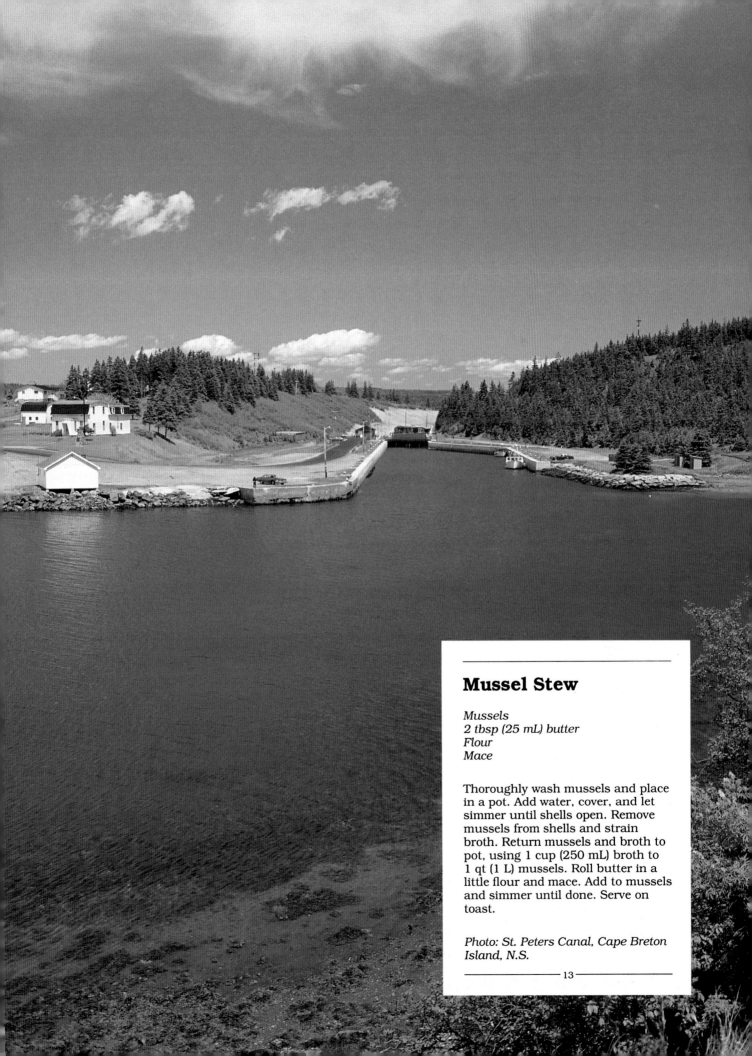

Mussel Stew

Mussels
2 tbsp (25 mL) butter
Flour
Mace

Thoroughly wash mussels and place
in a pot. Add water, cover, and let
simmer until shells open. Remove
mussels from shells and strain
broth. Return mussels and broth to
pot, using 1 cup (250 mL) broth to
1 qt (1 L) mussels. Roll butter in a
little flour and mace. Add to mussels
and simmer until done. Serve on
toast.

*Photo: St. Peters Canal, Cape Breton
Island, N.S.*

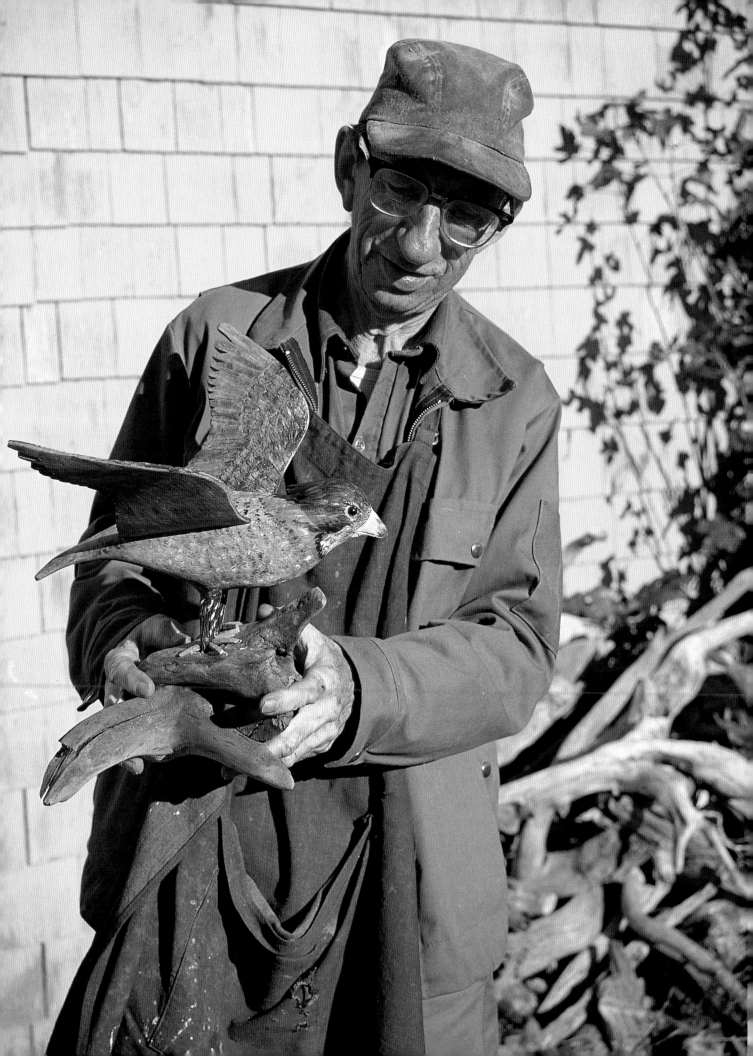

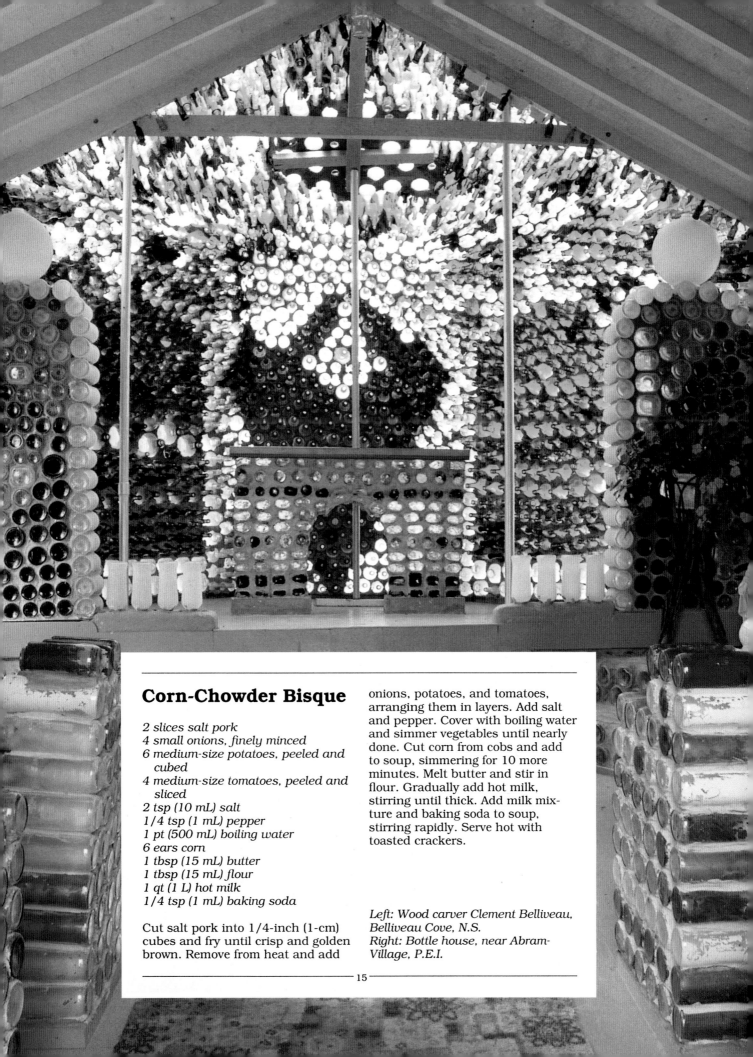

Corn-Chowder Bisque

2 slices salt pork
4 small onions, finely minced
6 medium-size potatoes, peeled and
　　cubed
4 medium-size tomatoes, peeled and
　　sliced
2 tsp (10 mL) salt
1/4 tsp (1 mL) pepper
1 pt (500 mL) boiling water
6 ears corn
1 tbsp (15 mL) butter
1 tbsp (15 mL) flour
1 qt (1 L) hot milk
1/4 tsp (1 mL) baking soda

Cut salt pork into 1/4-inch (1-cm) cubes and fry until crisp and golden brown. Remove from heat and add onions, potatoes, and tomatoes, arranging them in layers. Add salt and pepper. Cover with boiling water and simmer vegetables until nearly done. Cut corn from cobs and add to soup, simmering for 10 more minutes. Melt butter and stir in flour. Gradually add hot milk, stirring until thick. Add milk mixture and baking soda to soup, stirring rapidly. Serve hot with toasted crackers.

Left: Wood carver Clement Belliveau, Belliveau Cove, N.S.
Right: Bottle house, near Abram-Village, P.E.I.

15

Fish Chowder

1/2 lb (250 g) salt pork, diced
1 medium-size onion, diced
2 cups (500 mL) boiling water
3 cups (750 mL) peeled, diced
 potatoes
4 cups (1 L) milk
8 soda crackers, crumbled
2 tbsp (25 mL) butter
2 tsp (10 mL) salt
1/8 tsp (1 mL) pepper
2 tbsp (25 mL) finely chopped
 parsley
2 lb (1 kg) haddock fillets
Paprika

Fry salt pork until crisp. Add onion
and sauté until tender but not
brown. Add boiling water and
potatoes and cook for 10 minutes.
Combine milk, crackers, butter,
salt, pepper, and parsley. Heat to
scalding but do not boil. Meanwhile,
cut fillets into 2-inch (5-cm) pieces.
Poach in scalded milk for 5 minutes.
Add milk mixture to potato mixture.
Pour into soup tureen or individual
bowls and sprinkle with paprika.
Serves 6.

Left: Cape Jack, Havre Boucher, N.S.
Right: Île Miscou, N.B.

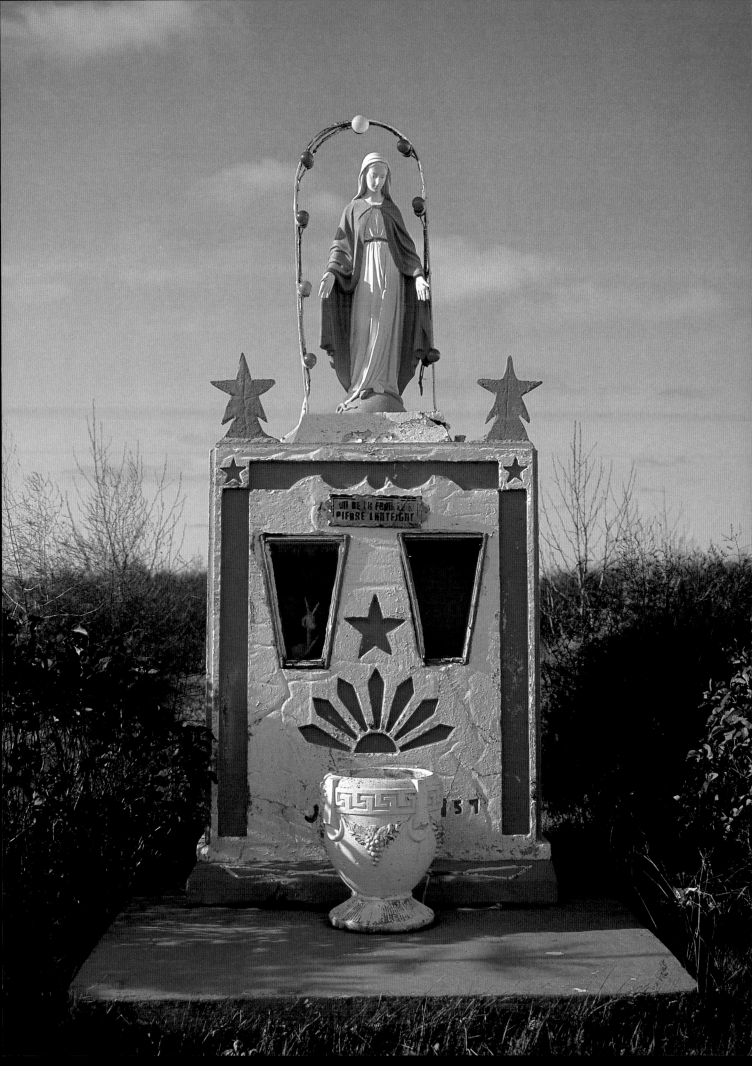

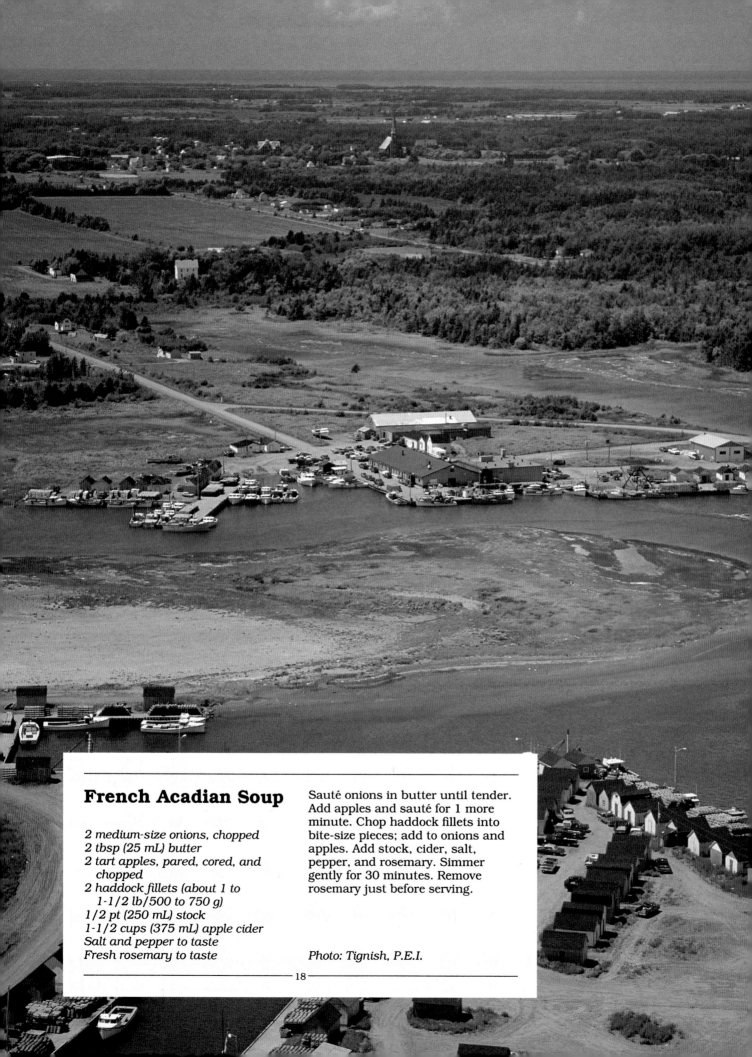

French Acadian Soup

2 medium-size onions, chopped
2 tbsp (25 mL) butter
2 tart apples, pared, cored, and
 chopped
2 haddock fillets (about 1 to
 1-1/2 lb/500 to 750 g)
1/2 pt (250 mL) stock
1-1/2 cups (375 mL) apple cider
Salt and pepper to taste
Fresh rosemary to taste

Sauté onions in butter until tender.
Add apples and sauté for 1 more
minute. Chop haddock fillets into
bite-size pieces; add to onions and
apples. Add stock, cider, salt,
pepper, and rosemary. Simmer
gently for 30 minutes. Remove
rosemary just before serving.

Photo: Tignish, P.E.I.

18

Vegetable Soup

1/2 cup (125 mL) barley
10 cups (2.5 L) stock
1 tbsp (15 mL) salt
1/2 tsp (2 mL) pepper
Herbs to taste
1 large onion, chopped
2 medium-size potatoes, peeled and
 cubed
1 large carrot, diced
1/2 cup (125 mL) kernel corn
1/2 cup (125 mL) chopped green or
 yellow string beans
1/2 cup (125 mL) grated cabbage
1/2 cup (125 mL) diced turnip
1/2 cup (125 mL) green peas

Soak barley in water for 1 hour and drain. Meanwhile, combine stock, salt, pepper, herbs, and onion. Bring to a boil. Reduce heat, add barley, and simmer for 30 minutes. Add potatoes and vegetables and simmer until tender.

Photo: Tracadie, N.S.

19

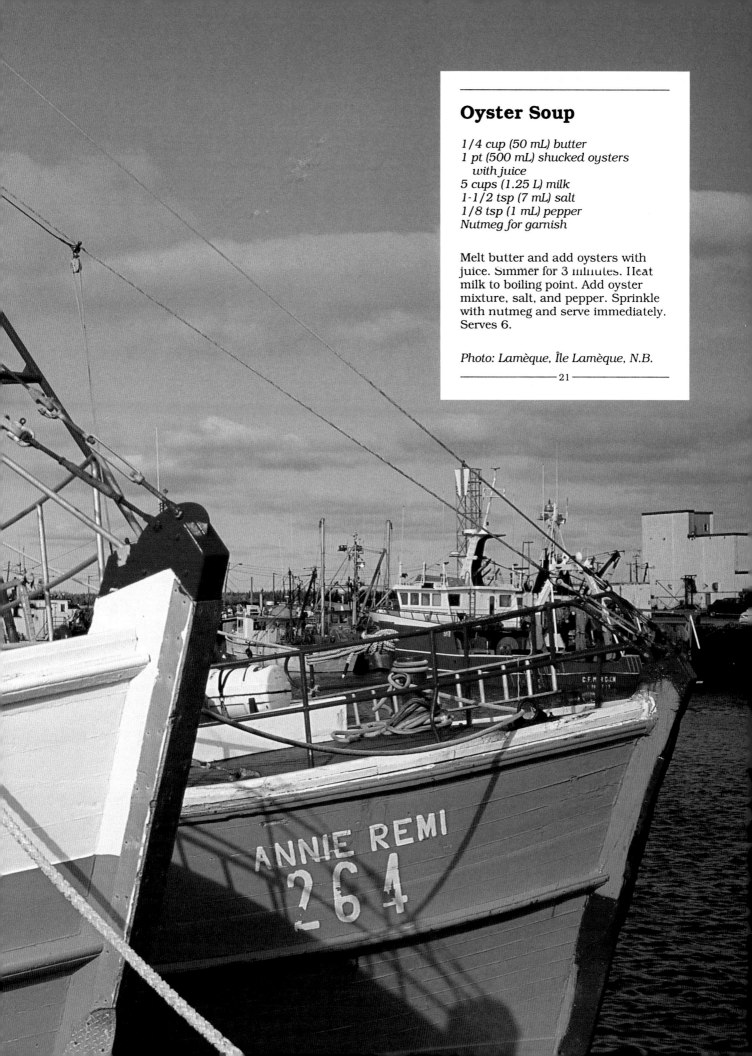

Oyster Soup

1/4 cup (50 mL) butter
1 pt (500 mL) shucked oysters
 with juice
5 cups (1.25 L) milk
1-1/2 tsp (7 mL) salt
1/8 tsp (1 mL) pepper
Nutmeg for garnish

Melt butter and add oysters with juice. Simmer for 3 minutes. Heat milk to boiling point. Add oyster mixture, salt, and pepper. Sprinkle with nutmeg and serve immediately. Serves 6.

Photo: Lamèque, Île Lamèque, N.B.

———————— 21 ————————

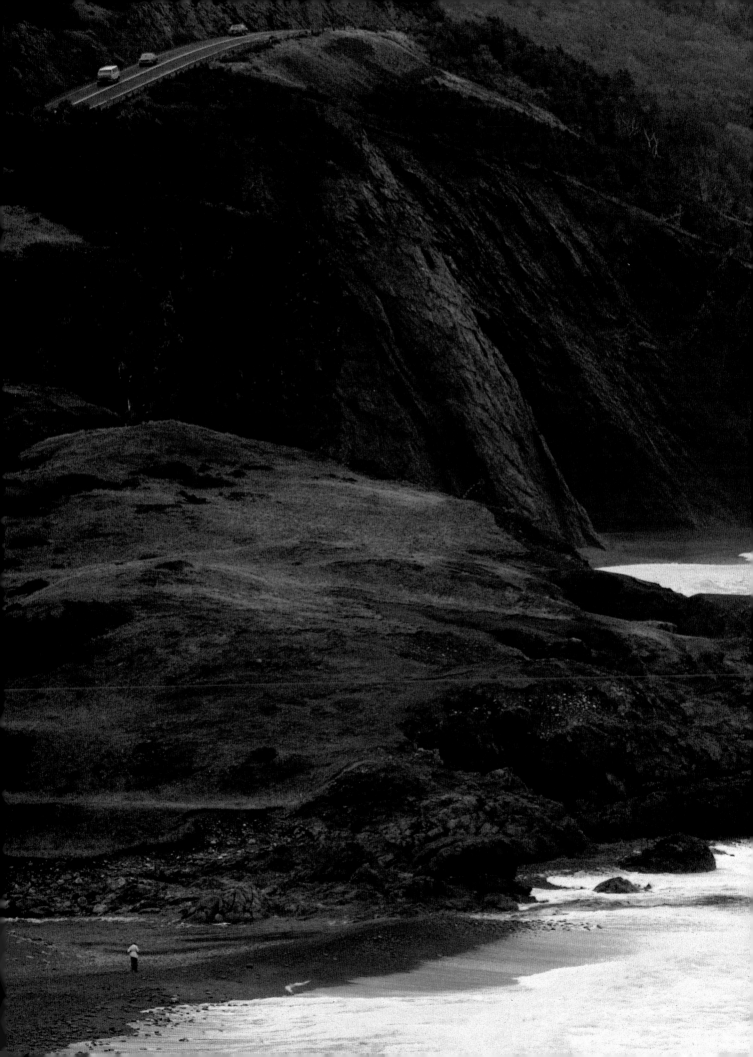

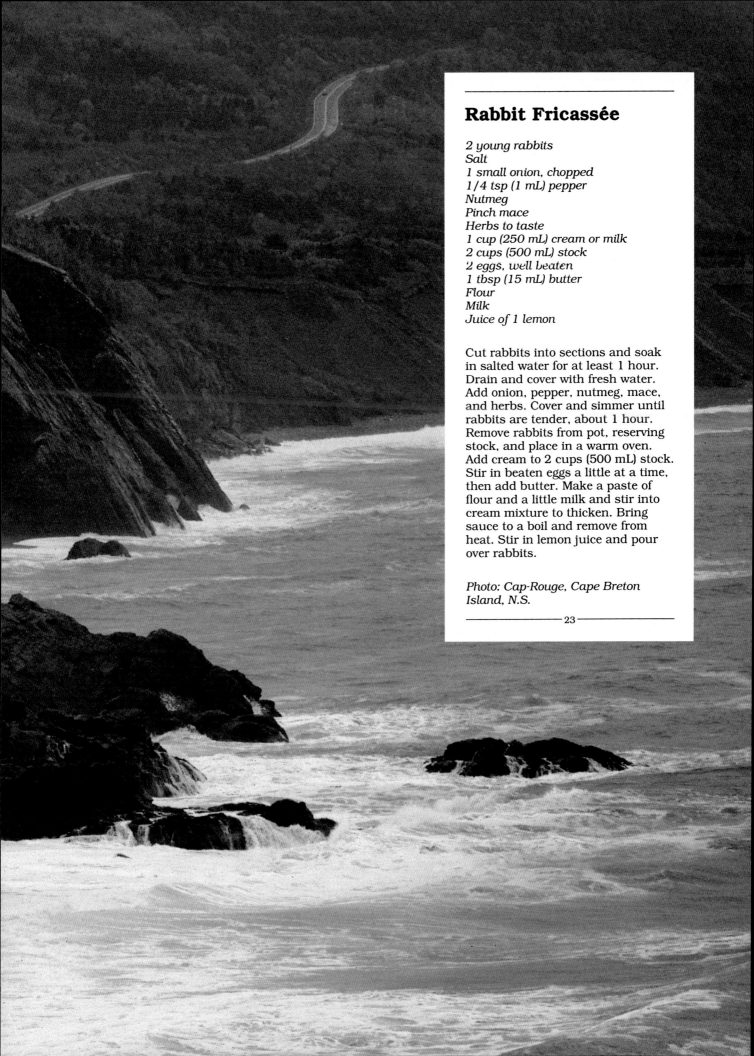

Rabbit Fricassée

2 young rabbits
Salt
1 small onion, chopped
1/4 tsp (1 mL) pepper
Nutmeg
Pinch mace
Herbs to taste
1 cup (250 mL) cream or milk
2 cups (500 mL) stock
2 eggs, well beaten
1 tbsp (15 mL) butter
Flour
Milk
Juice of 1 lemon

Cut rabbits into sections and soak
in salted water for at least 1 hour.
Drain and cover with fresh water.
Add onion, pepper, nutmeg, mace,
and herbs. Cover and simmer until
rabbits are tender, about 1 hour.
Remove rabbits from pot, reserving
stock, and place in a warm oven.
Add cream to 2 cups (500 mL) stock.
Stir in beaten eggs a little at a time,
then add butter. Make a paste of
flour and a little milk and stir into
cream mixture to thicken. Bring
sauce to a boil and remove from
heat. Stir in lemon juice and pour
over rabbits.

*Photo: Cap-Rouge, Cape Breton
Island, N.S.*

23

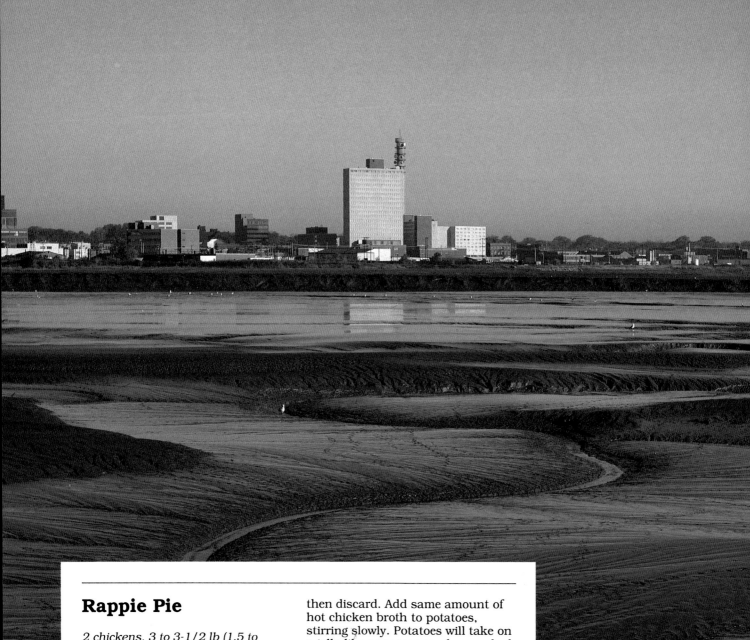

Rappie Pie

2 chickens, 3 to 3-1/2 lb (1.5 to
 1.625 kg) each
Salt and pepper to taste
Poultry seasoning to taste
Chopped onion
1 peck (8 kg) potatoes
1/4 lb (125 g) butter
6 strips bacon

Combine chicken, salt, pepper, poultry seasoning, and plenty of chopped onion. Add water and simmer until cooked. Separate meat from bones and cut into pieces; reserve broth. While chicken is cooking, peel potatoes and soak in cold water. Grate about 10 potatoes at a time, then place in a cloth bag (preferably a small flour bag) and squeeze until all water and starch is removed. Reserve liquid from potatoes. Loosen squeezed potatoes into a large pan. Measure potato liquid, then discard. Add same amount of hot chicken broth to potatoes, stirring slowly. Potatoes will take on a jelly-like appearance when cooked enough. Make sure there are no lumps. Add more salt, pepper, and poultry seasoning, stirring thoroughly. Grease a 12-inch x 17-inch x 2-inch (30-cm x 43-cm x 5-cm) pan and cover bottom with half of potato mixture. Arrange chicken, chopped onion, then pats of butter on top, distributing evenly. Cover with remaining potato mixture. Add a little chopped onion, more pats of butter, and bacon. Bake pie in a 400°F (200°C) oven for about 2 hours or until a brown crust forms. Serve with applesauce, cranberry sauce, or butter and molasses. Serves 12.

Left: Moncton, N.B.
Right: Saulnierville, N.S.

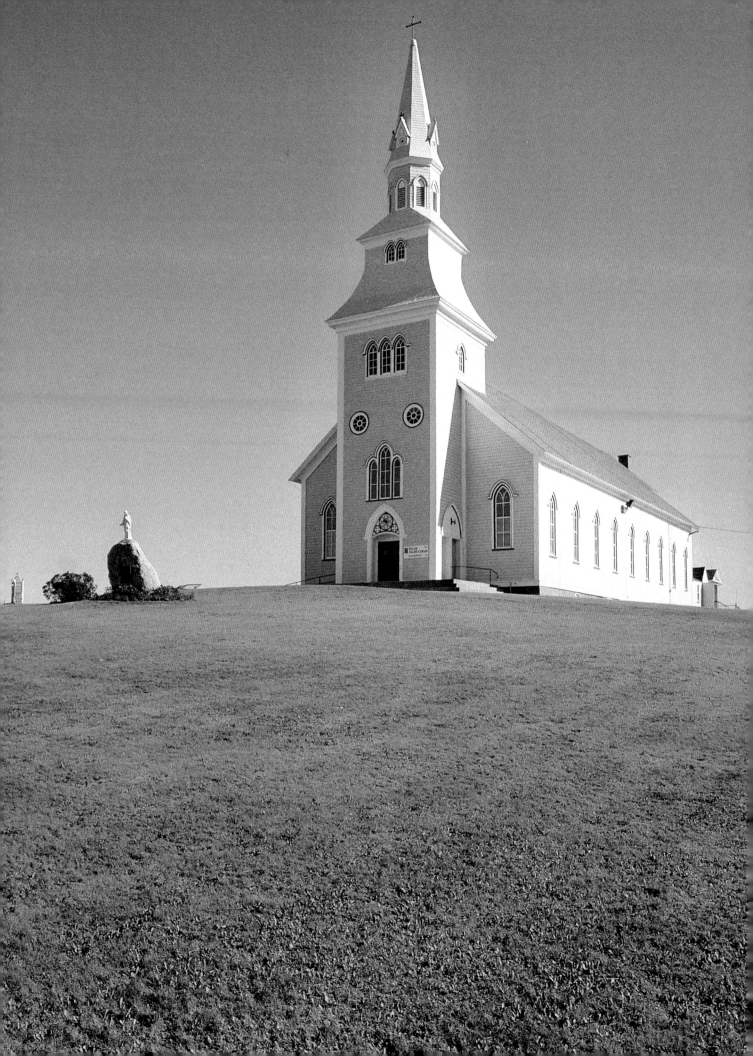

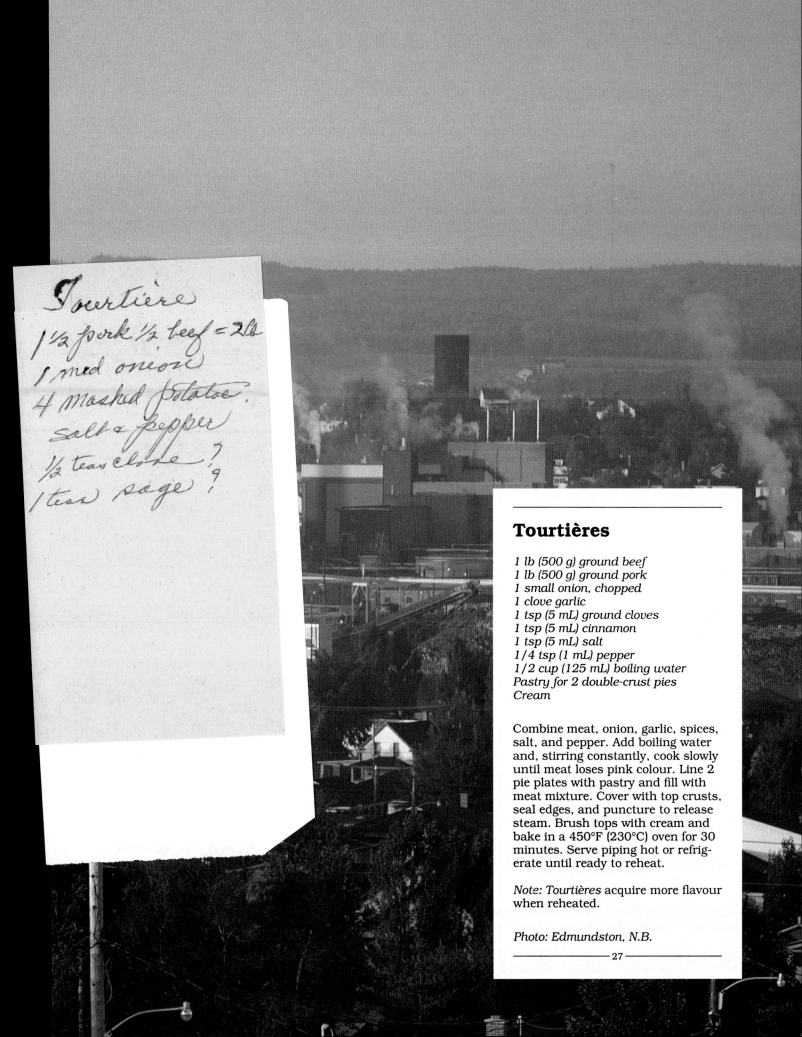

Tourtière
1 ½ pork ½ beef = 2 lb
1 med onion
4 mashed potatoe.
salt & pepper
½ teas clove ?
1 teas sage ?

Tourtières

1 lb (500 g) ground beef
1 lb (500 g) ground pork
1 small onion, chopped
1 clove garlic
1 tsp (5 mL) ground cloves
1 tsp (5 mL) cinnamon
1 tsp (5 mL) salt
1/4 tsp (1 mL) pepper
1/2 cup (125 mL) boiling water
Pastry for 2 double-crust pies
Cream

Combine meat, onion, garlic, spices, salt, and pepper. Add boiling water and, stirring constantly, cook slowly until meat loses pink colour. Line 2 pie plates with pastry and fill with meat mixture. Cover with top crusts, seal edges, and puncture to release steam. Brush tops with cream and bake in a 450°F (230°C) oven for 30 minutes. Serve piping hot or refrigerate until ready to reheat.

Note: Tourtières acquire more flavour when reheated.

Photo: Edmundston, N.B.

Partridge with Cabbage

2 partridges
Salt and pepper
1 large apple, cored, peeled, and
 diced
3 stalks celery, diced
2 slices bacon or salt pork
1 large onion, quartered
Butter
1 head cabbage, cored and quartered

Pluck, clean, and wash partridges, rinsing inside cavity well with cold water. Season with salt and pepper inside and out. Make a dressing out of apple and celery; stuff partridges. Tie bacon or salt pork over breasts and place partridges in a deep roasting pan. Add onion pieces. Butter outside of partridges and bake in a 350°F (180°C) oven for 45 minutes or until partially cooked. Meanwhile, boil cabbage until half cooked. Drain and place around partridges. Bake for 45 more minutes or until done. Make gravy with drippings.

Photo: Acadian Pioneer Village, Mont-Carmel, P.E.I.

28

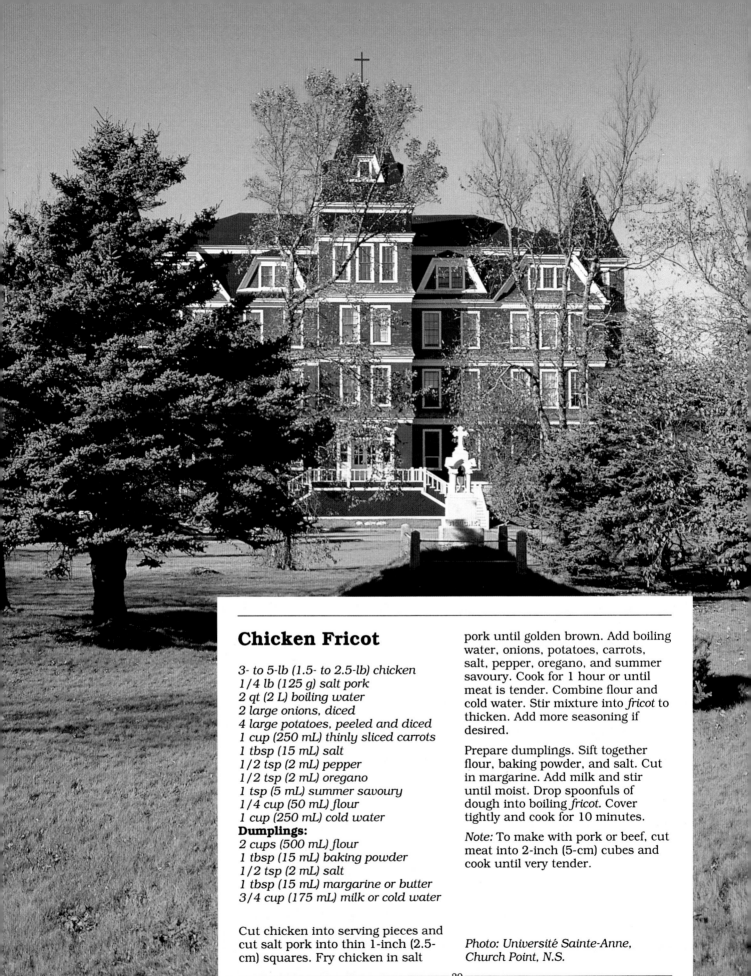

Chicken Fricot

3- to 5-lb (1.5- to 2.5-lb) chicken
1/4 lb (125 g) salt pork
2 qt (2 L) boiling water
2 large onions, diced
4 large potatoes, peeled and diced
1 cup (250 mL) thinly sliced carrots
1 tbsp (15 mL) salt
1/2 tsp (2 mL) pepper
1/2 tsp (2 mL) oregano
1 tsp (5 mL) summer savoury
1/4 cup (50 mL) flour
1 cup (250 mL) cold water
Dumplings:
2 cups (500 mL) flour
1 tbsp (15 mL) baking powder
1/2 tsp (2 mL) salt
1 tbsp (15 mL) margarine or butter
3/4 cup (175 mL) milk or cold water

Cut chicken into serving pieces and cut salt pork into thin 1-inch (2.5-cm) squares. Fry chicken in salt pork until golden brown. Add boiling water, onions, potatoes, carrots, salt, pepper, oregano, and summer savoury. Cook for 1 hour or until meat is tender. Combine flour and cold water. Stir mixture into *fricot* to thicken. Add more seasoning if desired.

Prepare dumplings. Sift together flour, baking powder, and salt. Cut in margarine. Add milk and stir until moist. Drop spoonfuls of dough into boiling *fricot*. Cover tightly and cook for 10 minutes.

Note: To make with pork or beef, cut meat into 2-inch (5-cm) cubes and cook until very tender.

Photo: Université Sainte-Anne, Church Point, N.S.

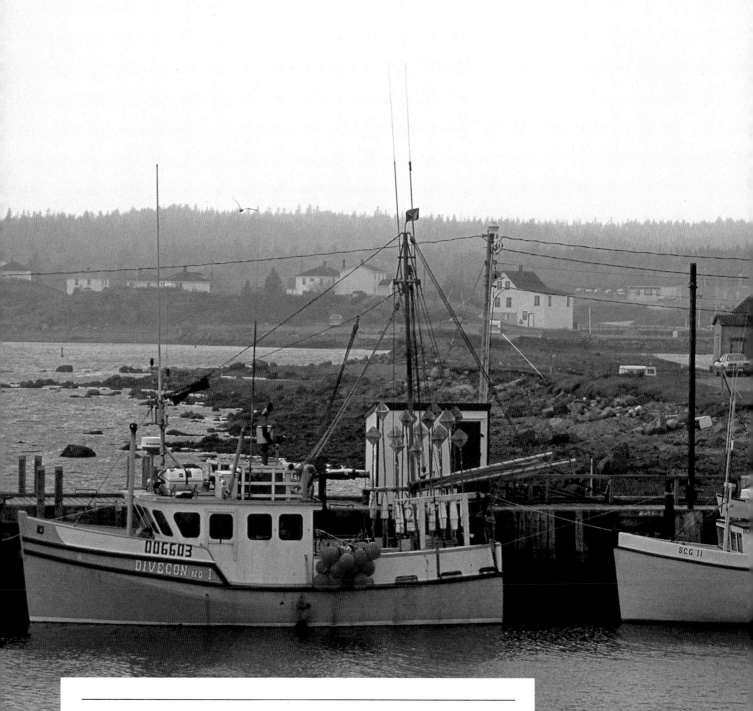

Acadian Meat Pie

Potatoes, peeled and cubed
Chicken, rabbit, or pork, cut into
 pieces
Minced onion
Salt and pepper to taste
Biscuit dough

Place a layer of potatoes in bottom
of a greased deep pan. Add a layer of
meat, onion, salt, and pepper. Cover
with strips of biscuit dough. Repeat
layers until pan is 3/4 full. Add hot
water to level of last layer. Cover
with a round of 1/2-inch thick
biscuit dough. Make an incision in
centre of biscuit dough and cook on
top of stove for 4 to 5 hours.

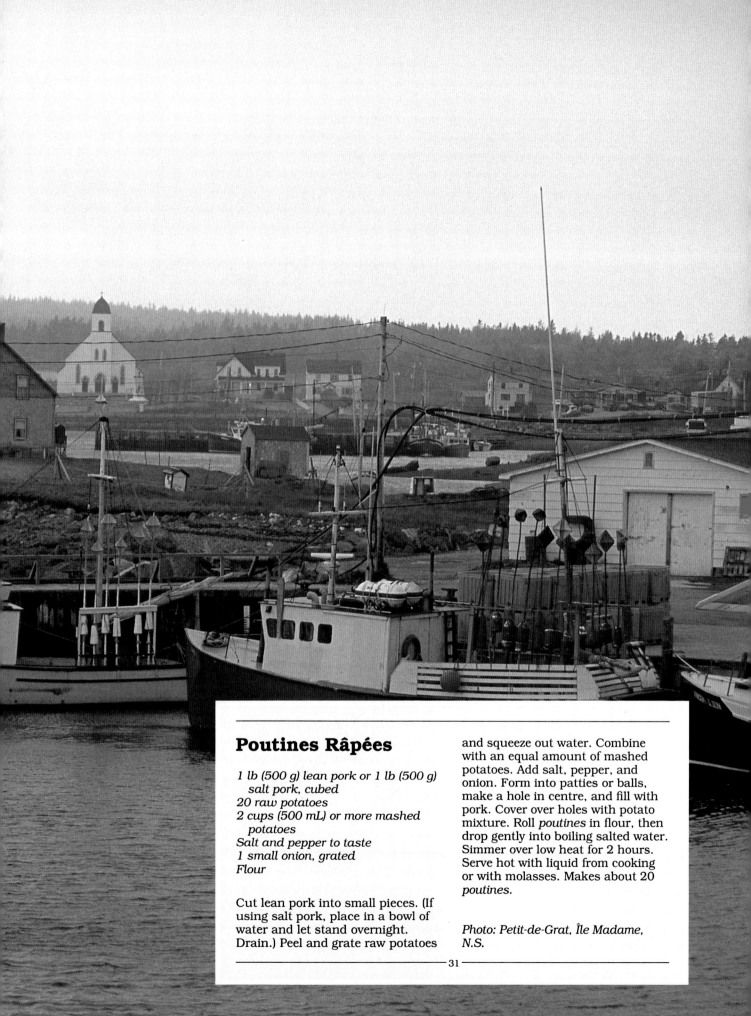

Poutines Râpées

1 lb (500 g) lean pork or 1 lb (500 g)
 salt pork, cubed
20 raw potatoes
2 cups (500 mL) or more mashed
 potatoes
Salt and pepper to taste
1 small onion, grated
Flour

Cut lean pork into small pieces. (If using salt pork, place in a bowl of water and let stand overnight. Drain.) Peel and grate raw potatoes and squeeze out water. Combine with an equal amount of mashed potatoes. Add salt, pepper, and onion. Form into patties or balls, make a hole in centre, and fill with pork. Cover over holes with potato mixture. Roll *poutines* in flour, then drop gently into boiling salted water. Simmer over low heat for 2 hours. Serve hot with liquid from cooking or with molasses. Makes about 20 *poutines*.

Photo: Petit-de-Grat, Île Madame, N.S.

31

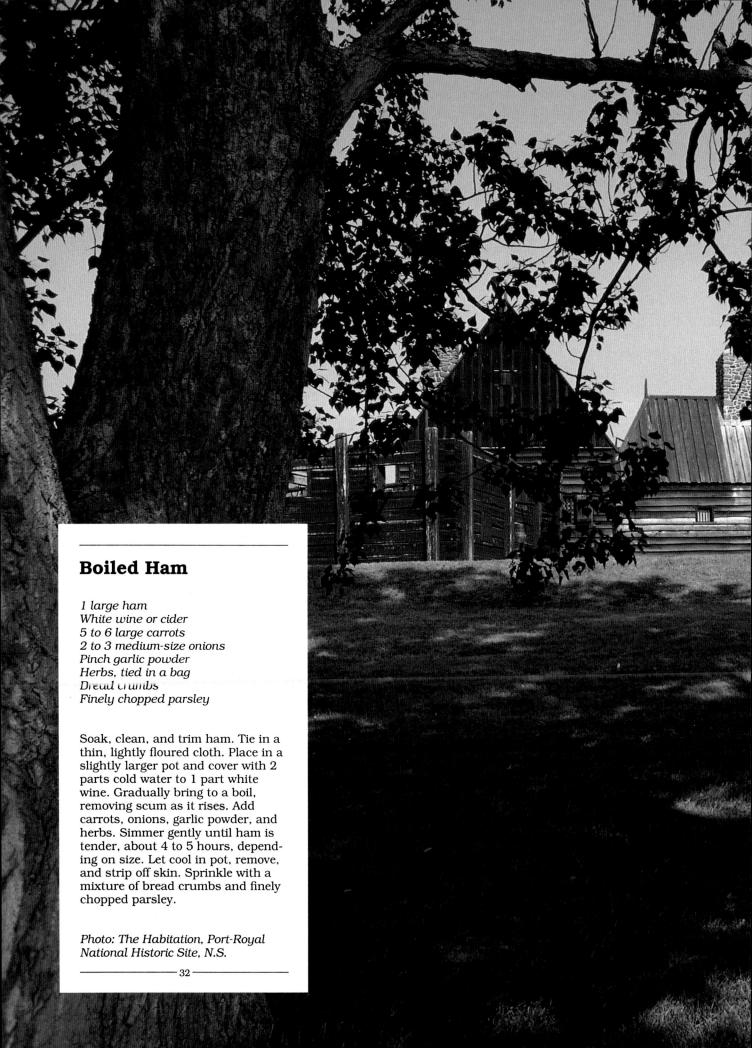

Boiled Ham

1 large ham
White wine or cider
5 to 6 large carrots
2 to 3 medium-size onions
Pinch garlic powder
Herbs, tied in a bag
Bread crumbs
Finely chopped parsley

Soak, clean, and trim ham. Tie in a thin, lightly floured cloth. Place in a slightly larger pot and cover with 2 parts cold water to 1 part white wine. Gradually bring to a boil, removing scum as it rises. Add carrots, onions, garlic powder, and herbs. Simmer gently until ham is tender, about 4 to 5 hours, depending on size. Let cool in pot, remove, and strip off skin. Sprinkle with a mixture of bread crumbs and finely chopped parsley.

Photo: The Habitation, Port-Royal National Historic Site, N.S.

32

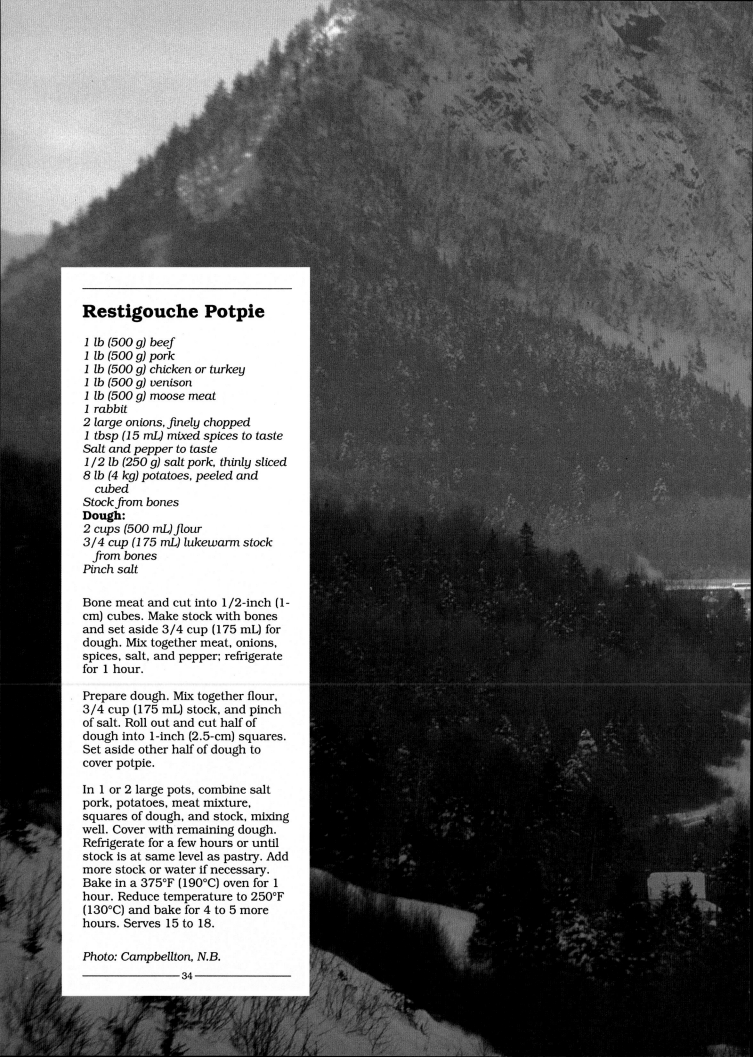

Restigouche Potpie

1 lb (500 g) beef
1 lb (500 g) pork
1 lb (500 g) chicken or turkey
1 lb (500 g) venison
1 lb (500 g) moose meat
1 rabbit
2 large onions, finely chopped
1 tbsp (15 mL) mixed spices to taste
Salt and pepper to taste
1/2 lb (250 g) salt pork, thinly sliced
8 lb (4 kg) potatoes, peeled and
* cubed*
Stock from bones
Dough:
2 cups (500 mL) flour
3/4 cup (175 mL) lukewarm stock
* from bones*
Pinch salt

Bone meat and cut into 1/2-inch (1-cm) cubes. Make stock with bones and set aside 3/4 cup (175 mL) for dough. Mix together meat, onions, spices, salt, and pepper; refrigerate for 1 hour.

Prepare dough. Mix together flour, 3/4 cup (175 mL) stock, and pinch of salt. Roll out and cut half of dough into 1-inch (2.5-cm) squares. Set aside other half of dough to cover potpie.

In 1 or 2 large pots, combine salt pork, potatoes, meat mixture, squares of dough, and stock, mixing well. Cover with remaining dough. Refrigerate for a few hours or until stock is at same level as pastry. Add more stock or water if necessary. Bake in a 375°F (190°C) oven for 1 hour. Reduce temperature to 250°F (130°C) and bake for 4 to 5 more hours. Serves 15 to 18.

Photo: Campbellton, N.B.

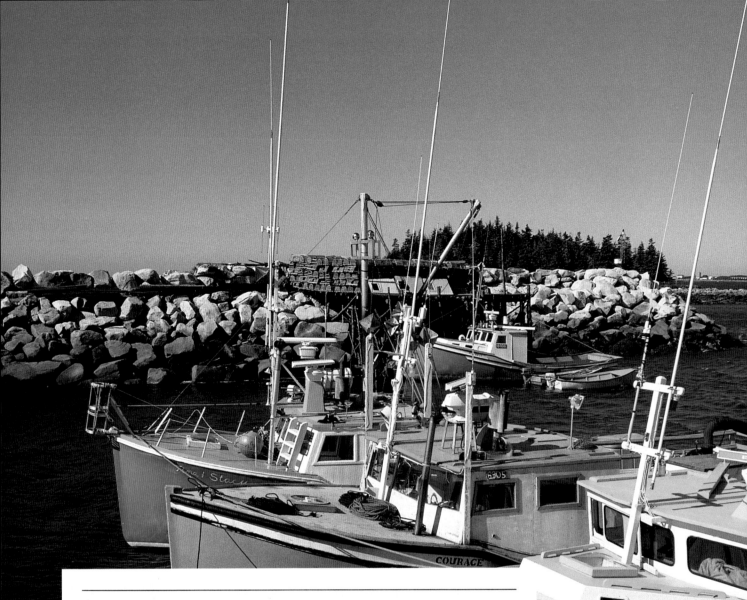

Seafood Casserole

1/2 tsp (2 mL) salt
1 cup (250 mL) milk
1 lb (500 g) scallops
1 8 oz (227-g) container crab meat
1 11.3-oz (320-g) can lobster meat
1/4 cup (50 mL) margarine or butter
2 cups (500 mL) chopped onion
3 cups (750 mL) chopped celery
3/4 cup (175 mL) flour
1 tsp (5 mL) salt
1/4 tsp (1 mL) white pepper
1/2 cup (125 mL) margarine or butter
4 cups (1 L) cold milk
1 lb (500 g) Cheddar cheese, grated
12 oz (300 g) shrimp, cooked and
 deveined
Croutons (optional)

Combine 1/2 tsp (2 mL) salt and 1 cup (250 mL) milk; scald. Poach scallops in scalded milk for 3 to 5 minutes or until flesh is opaque. Drain and reserve milk. Drain crab and lobster and remove cartilage.

Cut into small pieces. Melt 1/4 cup (50 mL) margarine and sauté onion and celery. Combine flour, 1 tsp (5 mL) salt, and white pepper. Melt 1/2 cup (125 mL) margarine, blend in seasoned flour, and cook on low heat for 2 minutes. Gradually add 4 cups (1 L) cold milk and reserved hot milk, stirring until thick and smooth. Add cheese, stirring until melted. Season further to taste if necessary. Add scallops, crab, lobster, and shrimp. Place in a large casserole and bake in a 400°F (200°C) oven for 20 to 30 minutes or until bubbly. If desired, top with croutons and continue cooking until golden brown. Serves 12.

Left: Lower West Pubnico, N.S.
Right: Crab traps, Shippagan, N.B.

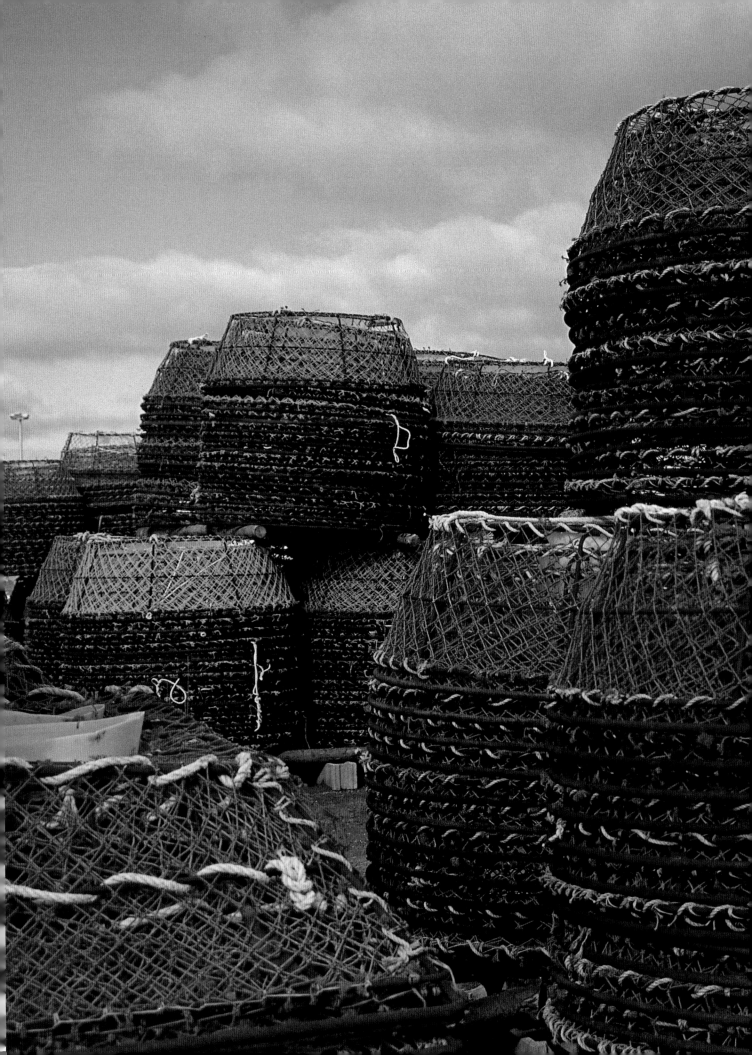

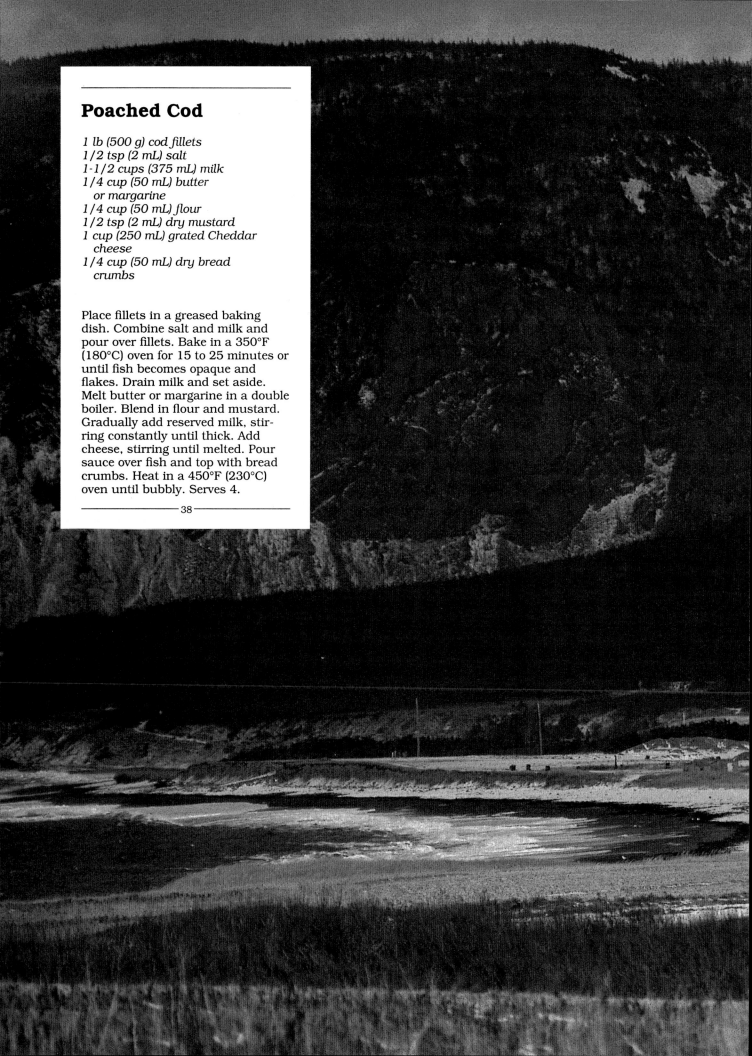

Poached Cod

1 lb (500 g) cod fillets
1/2 tsp (2 mL) salt
1-1/2 cups (375 mL) milk
1/4 cup (50 mL) butter
* or margarine*
1/4 cup (50 mL) flour
1/2 tsp (2 mL) dry mustard
1 cup (250 mL) grated Cheddar
* cheese*
1/4 cup (50 mL) dry bread
* crumbs*

Place fillets in a greased baking
dish. Combine salt and milk and
pour over fillets. Bake in a 350°F
(180°C) oven for 15 to 25 minutes or
until fish becomes opaque and
flakes. Drain milk and set aside.
Melt butter or margarine in a double
boiler. Blend in flour and mustard.
Gradually add reserved milk, stir-
ring constantly until thick. Add
cheese, stirring until melted. Pour
sauce over fish and top with bread
crumbs. Heat in a 450°F (230°C)
oven until bubbly. Serves 4.

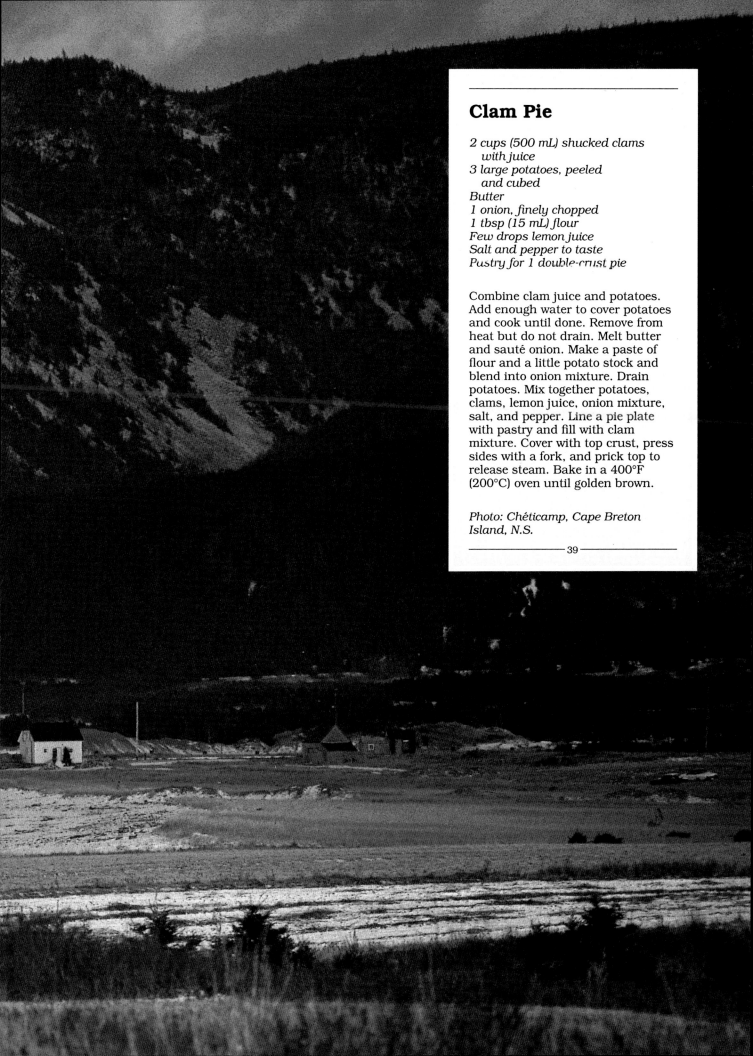

Clam Pie

*2 cups (500 mL) shucked clams
 with juice
3 large potatoes, peeled
 and cubed
Butter
1 onion, finely chopped
1 tbsp (15 mL) flour
Few drops lemon juice
Salt and pepper to taste
Pastry for 1 double-crust pie*

Combine clam juice and potatoes.
Add enough water to cover potatoes
and cook until done. Remove from
heat but do not drain. Melt butter
and sauté onion. Make a paste of
flour and a little potato stock and
blend into onion mixture. Drain
potatoes. Mix together potatoes,
clams, lemon juice, onion mixture,
salt, and pepper. Line a pie plate
with pastry and fill with clam
mixture. Cover with top crust, press
sides with a fork, and prick top to
release steam. Bake in a 400°F
(200°C) oven until golden brown.

*Photo: Chéticamp, Cape Breton
Island, N.S.*

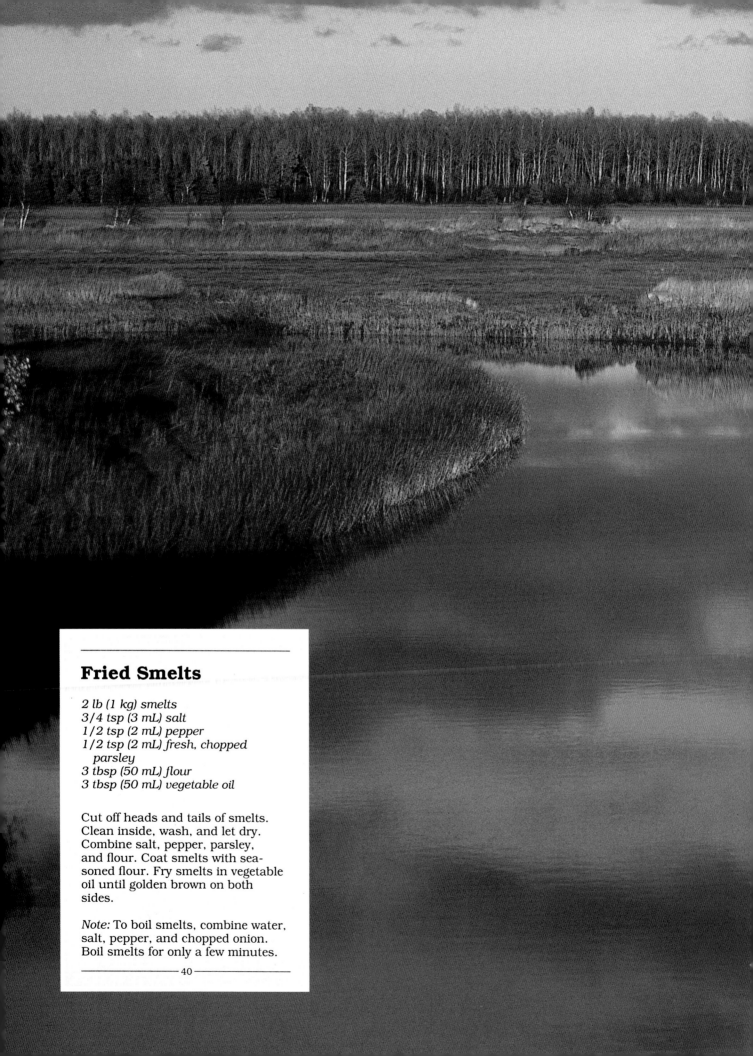

Fried Smelts

2 lb (1 kg) smelts
3/4 tsp (3 mL) salt
1/2 tsp (2 mL) pepper
1/2 tsp (2 mL) fresh, chopped
 parsley
3 tbsp (50 mL) flour
3 tbsp (50 mL) vegetable oil

Cut off heads and tails of smelts.
Clean inside, wash, and let dry.
Combine salt, pepper, parsley,
and flour. Coat smelts with sea-
soned flour. Fry smelts in vegetable
oil until golden brown on both
sides.

Note: To boil smelts, combine water,
salt, pepper, and chopped onion.
Boil smelts for only a few minutes.

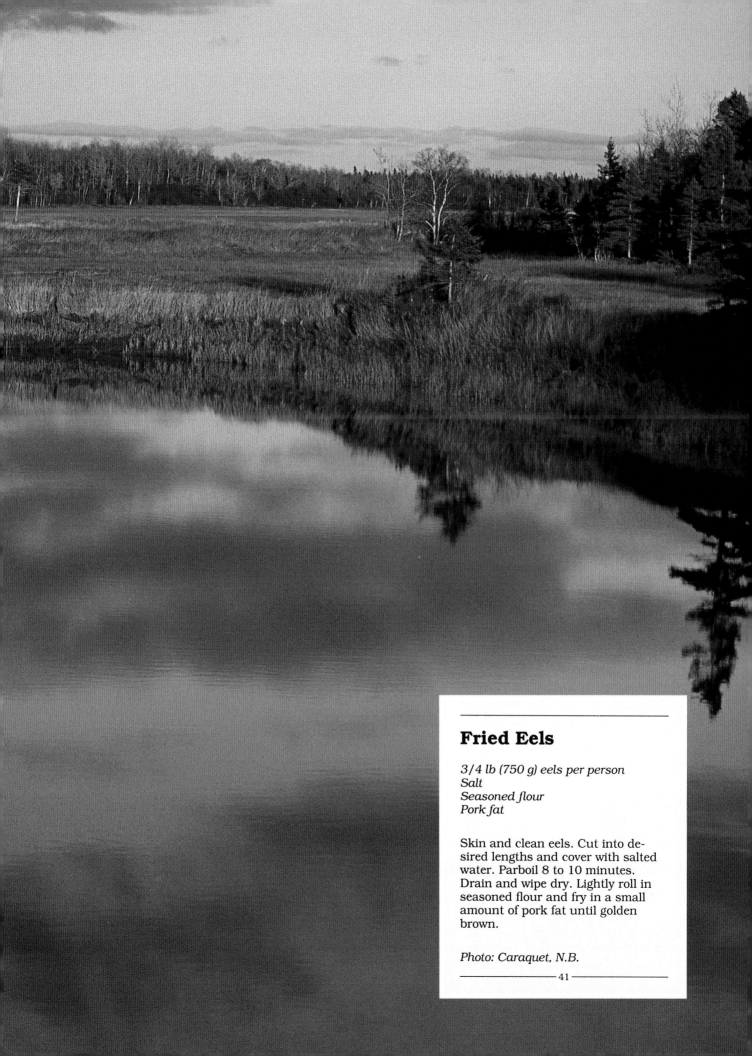

Fried Eels

3/4 lb (750 g) eels per person
Salt
Seasoned flour
Pork fat

Skin and clean eels. Cut into de-
sired lengths and cover with salted
water. Parboil 8 to 10 minutes.
Drain and wipe dry. Lightly roll in
seasoned flour and fry in a small
amount of pork fat until golden
brown.

Photo: Caraquet, N.B.

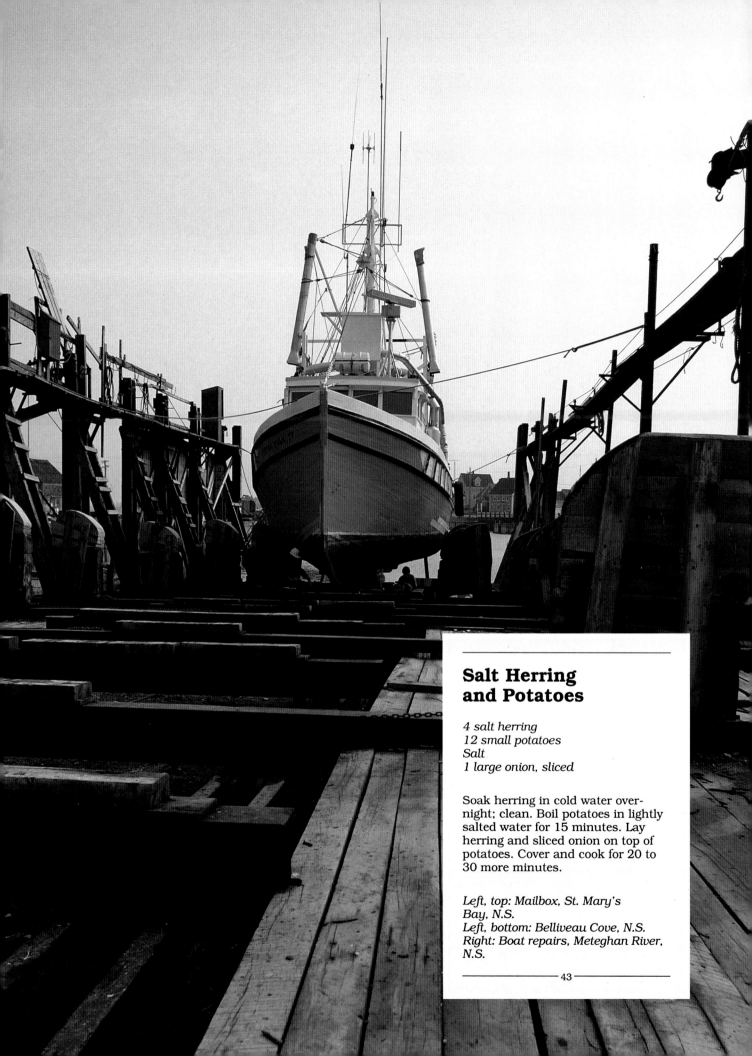

Salt Herring and Potatoes

4 salt herring
12 small potatoes
Salt
1 large onion, sliced

Soak herring in cold water overnight; clean. Boil potatoes in lightly salted water for 15 minutes. Lay herring and sliced onion on top of potatoes. Cover and cook for 20 to 30 more minutes.

Left, top: Mailbox, St. Mary's Bay, N.S.
Left, bottom: Belliveau Cove, N.S.
Right: Boat repairs, Meteghan River, N.S.

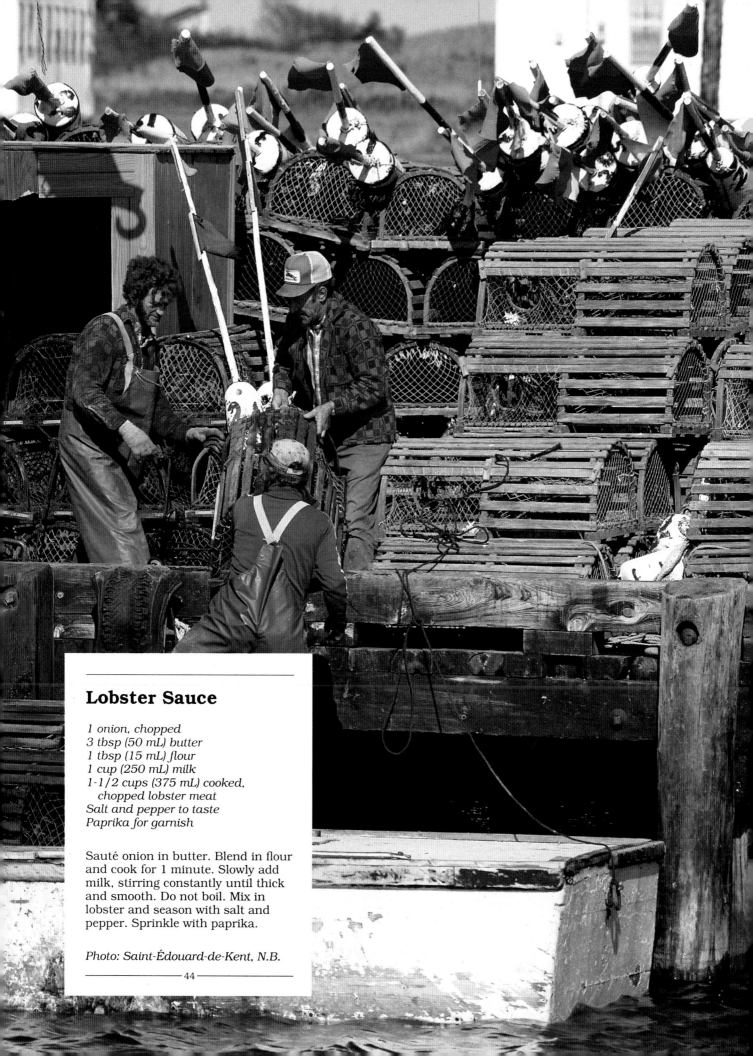

Lobster Sauce

1 onion, chopped
3 tbsp (50 mL) butter
1 tbsp (15 mL) flour
1 cup (250 mL) milk
1-1/2 cups (375 mL) cooked,
 chopped lobster meat
Salt and pepper to taste
Paprika for garnish

Sauté onion in butter. Blend in flour
and cook for 1 minute. Slowly add
milk, stirring constantly until thick
and smooth. Do not boil. Mix in
lobster and season with salt and
pepper. Sprinkle with paprika.

Photo: Saint-Édouard-de-Kent, N.B.

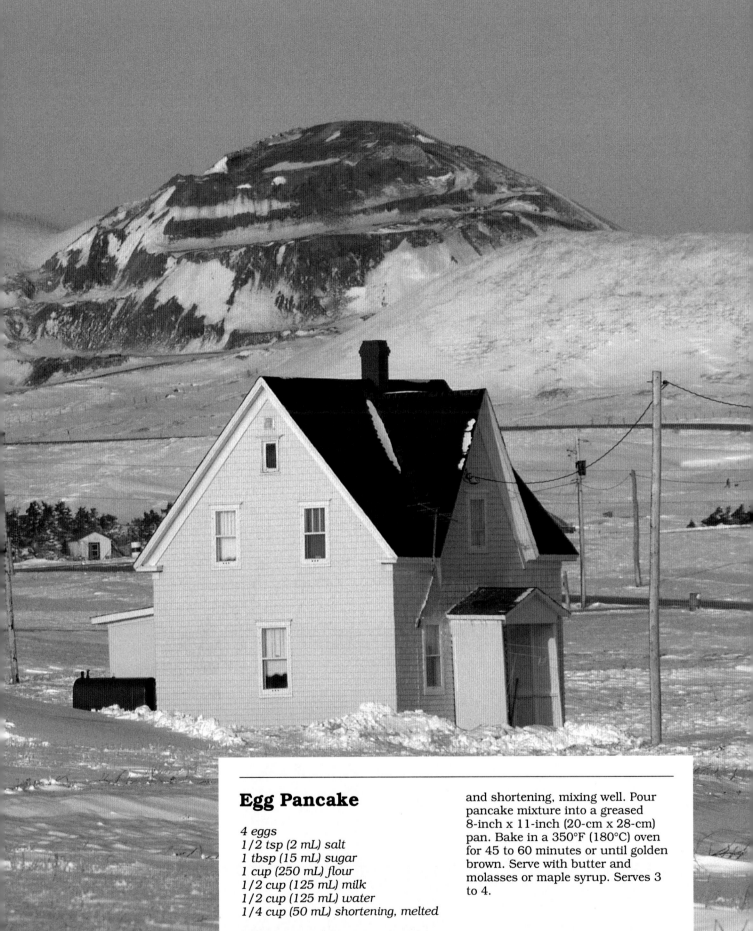

Egg Pancake

4 eggs
1/2 tsp (2 mL) salt
1 tbsp (15 mL) sugar
1 cup (250 mL) flour
1/2 cup (125 mL) milk
1/2 cup (125 mL) water
1/4 cup (50 mL) shortening, melted

Beat together eggs, salt, and sugar.
Gradually add flour, milk, water,
and shortening, mixing well. Pour
pancake mixture into a greased
8-inch x 11-inch (20-cm x 28-cm)
pan. Bake in a 350°F (180°C) oven
for 45 to 60 minutes or until golden
brown. Serve with butter and
molasses or maple syrup. Serves 3
to 4.

Photo: Îles de la Madeleine, Que.

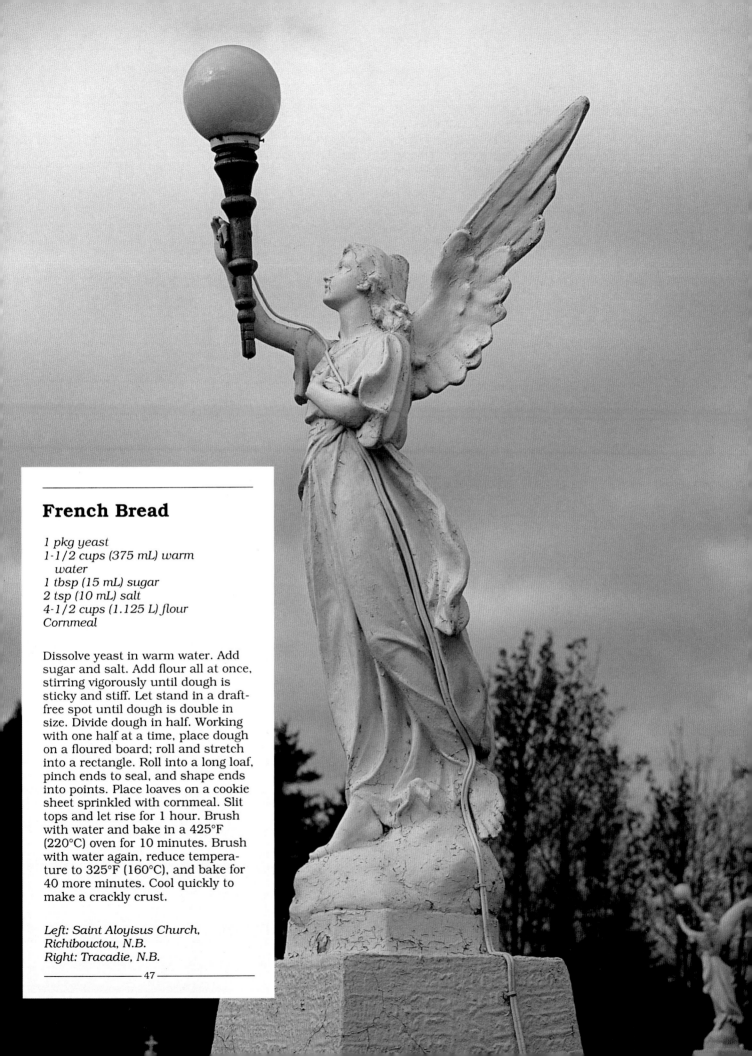

French Bread

1 pkg yeast
1-1/2 cups (375 mL) warm
 water
1 tbsp (15 mL) sugar
2 tsp (10 mL) salt
4-1/2 cups (1.125 L) flour
Cornmeal

Dissolve yeast in warm water. Add
sugar and salt. Add flour all at once,
stirring vigorously until dough is
sticky and stiff. Let stand in a draft-
free spot until dough is double in
size. Divide dough in half. Working
with one half at a time, place dough
on a floured board; roll and stretch
into a rectangle. Roll into a long loaf,
pinch ends to seal, and shape ends
into points. Place loaves on a cookie
sheet sprinkled with cornmeal. Slit
tops and let rise for 1 hour. Brush
with water and bake in a 425°F
(220°C) oven for 10 minutes. Brush
with water again, reduce tempera-
ture to 325°F (160°C), and bake for
40 more minutes. Cool quickly to
make a crackly crust.

Left: Saint Aloyisus Church,
Richibouctou, N.B.
Right: Tracadie, N.B.

47

Blueberry Muffins

1 egg
1/2 cup (125 mL) milk
1/4 cup (50 mL) shortening, melted
1-1/2 cups (375 mL) flour
2 tsp (10 mL) baking powder
1/2 tsp (2 mL) salt
1/2 cup (125 mL) sugar
1 cup (250 mL) blueberries

Lightly beat egg. Stir in milk and shortening. Sift together dry ingredients and add to milk mixture, stirring just enough to moisten flour. Lightly coat blueberries with flour and fold into batter. Spoon batter into greased muffin tins to 2/3 full and bake in a 400°F (200°C) oven for 20 to 25 minutes.

Photo: Sainte-Anne-du-Ruisseau, N.S.

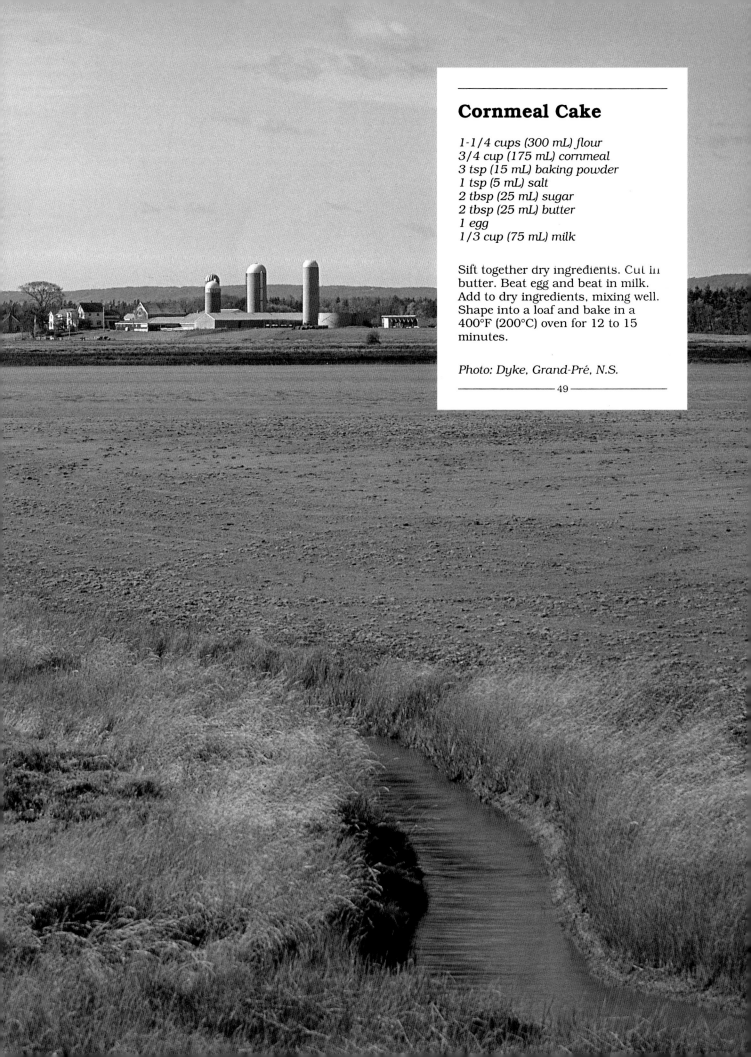

Cornmeal Cake

1-1/4 cups (300 mL) flour
3/4 cup (175 mL) cornmeal
3 tsp (15 mL) baking powder
1 tsp (5 mL) salt
2 tbsp (25 mL) sugar
2 tbsp (25 mL) butter
1 egg
1/3 cup (75 mL) milk

Sift together dry ingredients. Cut in butter. Beat egg and beat in milk. Add to dry ingredients, mixing well. Shape into a loaf and bake in a 400°F (200°C) oven for 12 to 15 minutes.

Photo: Dyke, Grand-Pré, N.S.

49

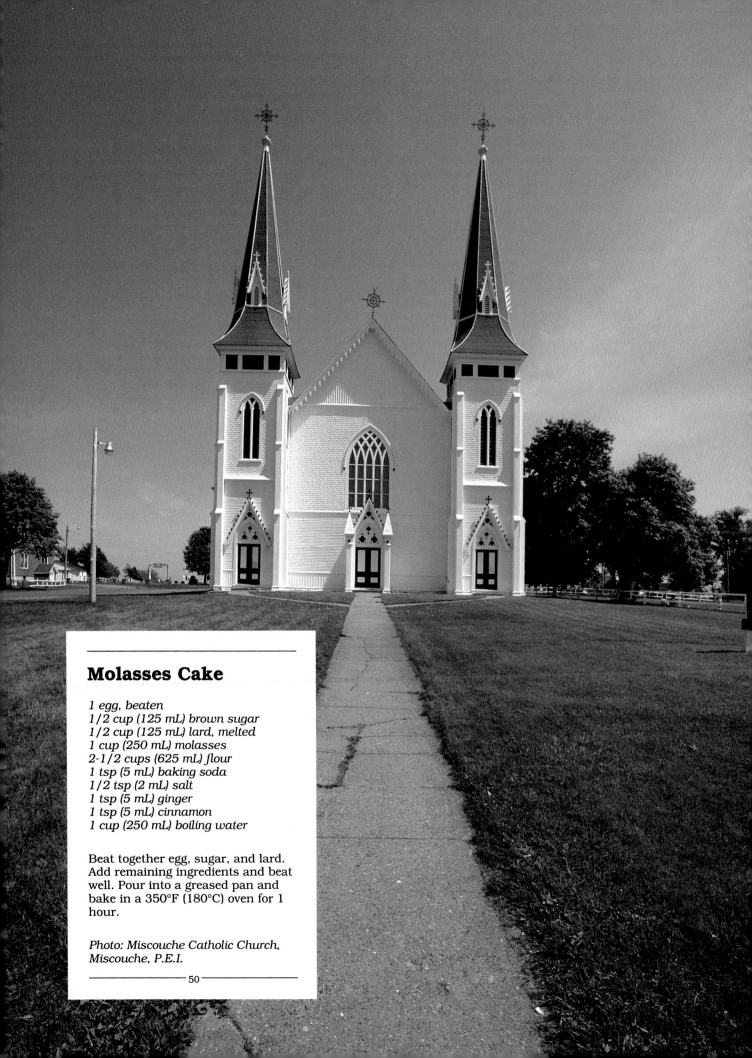

Molasses Cake

1 egg, beaten
1/2 cup (125 mL) brown sugar
1/2 cup (125 mL) lard, melted
1 cup (250 mL) molasses
2-1/2 cups (625 mL) flour
1 tsp (5 mL) baking soda
1/2 tsp (2 mL) salt
1 tsp (5 mL) ginger
1 tsp (5 mL) cinnamon
1 cup (250 mL) boiling water

Beat together egg, sugar, and lard.
Add remaining ingredients and beat
well. Pour into a greased pan and
bake in a 350°F (180°C) oven for 1
hour.

Photo: Miscouche Catholic Church,
Miscouche, P.E.I.

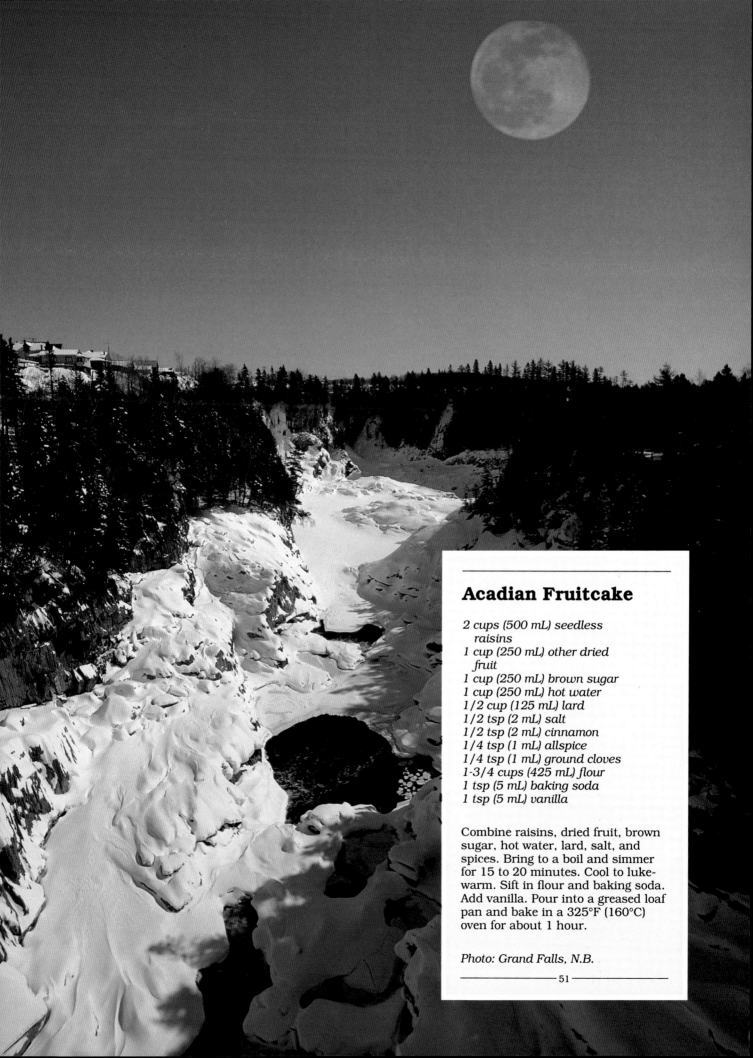

Acadian Fruitcake

2 cups (500 mL) seedless
 raisins
1 cup (250 mL) other dried
 fruit
1 cup (250 mL) brown sugar
1 cup (250 mL) hot water
1/2 cup (125 mL) lard
1/2 tsp (2 mL) salt
1/2 tsp (2 mL) cinnamon
1/4 tsp (1 mL) allspice
1/4 tsp (1 mL) ground cloves
1-3/4 cups (425 mL) flour
1 tsp (5 mL) baking soda
1 tsp (5 mL) vanilla

Combine raisins, dried fruit, brown
sugar, hot water, lard, salt, and
spices. Bring to a boil and simmer
for 15 to 20 minutes. Cool to luke-
warm. Sift in flour and baking soda.
Add vanilla. Pour into a greased loaf
pan and bake in a 325°F (160°C)
oven for about 1 hour.

Photo: Grand Falls, N.B.

Vinegar Pie

1-1/2 tbsp (20 mL) flour
3/4 cup (175 mL) sugar
2 tbsp (25 mL) vinegar
1/2 tsp (2 mL) salt
1 tbsp (15 mL) butter
2 egg yolks, beaten
1/4 cup (50 mL) milk
1 cup (250 mL) boiling water
1 tsp (5 mL) lemon extract
Baked pie shell
Meringue

Mix together flour and sugar. Add vinegar, salt, butter, and egg yolks. Beat mixture until creamy. Beat in milk and boiling water. Cook mixture in a double boiler until thick, stirring constantly. Stir in lemon extract. Pour into baked pie shell and top with meringue. Bake in a 350°F (180°C) oven until golden brown.

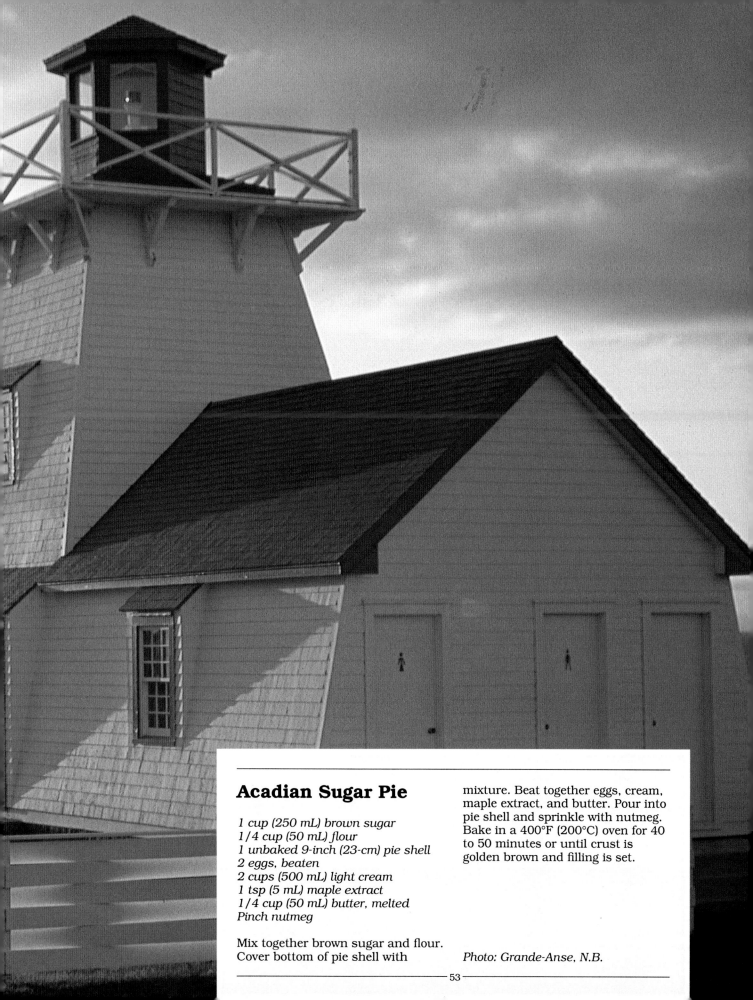

Acadian Sugar Pie

1 cup (250 mL) brown sugar
1/4 cup (50 mL) flour
1 unbaked 9-inch (23-cm) pie shell
2 eggs, beaten
2 cups (500 mL) light cream
1 tsp (5 mL) maple extract
1/4 cup (50 mL) butter, melted
Pinch nutmeg

Mix together brown sugar and flour.
Cover bottom of pie shell with

mixture. Beat together eggs, cream,
maple extract, and butter. Pour into
pie shell and sprinkle with nutmeg.
Bake in a 400°F (200°C) oven for 40
to 50 minutes or until crust is
golden brown and filling is set.

Photo: Grande-Anse, N.B.

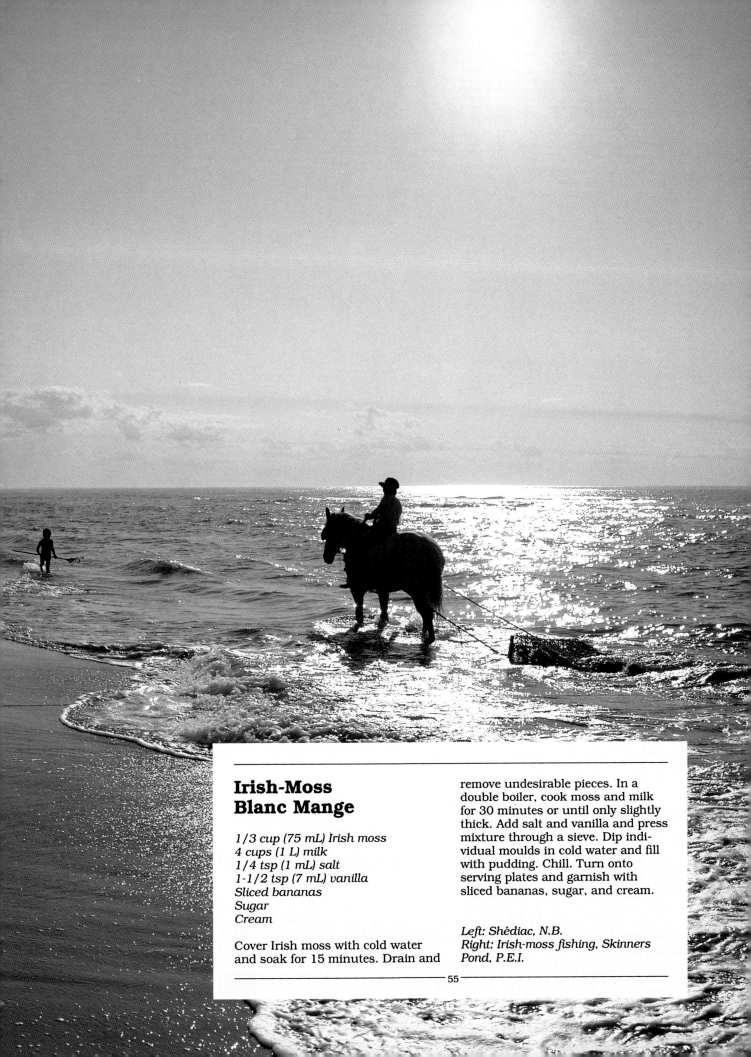

Irish-Moss
Blanc Mange

1/3 cup (75 mL) Irish moss
4 cups (1 L) milk
1/4 tsp (1 mL) salt
1-1/2 tsp (7 mL) vanilla
Sliced bananas
Sugar
Cream

Cover Irish moss with cold water
and soak for 15 minutes. Drain and
remove undesirable pieces. In a
double boiler, cook moss and milk
for 30 minutes or until only slightly
thick. Add salt and vanilla and press
mixture through a sieve. Dip indi-
vidual moulds in cold water and fill
with pudding. Chill. Turn onto
serving plates and garnish with
sliced bananas, sugar, and cream.

Left: Shédiac, N.B.
*Right: Irish-moss fishing, Skinners
Pond, P.E.I.*

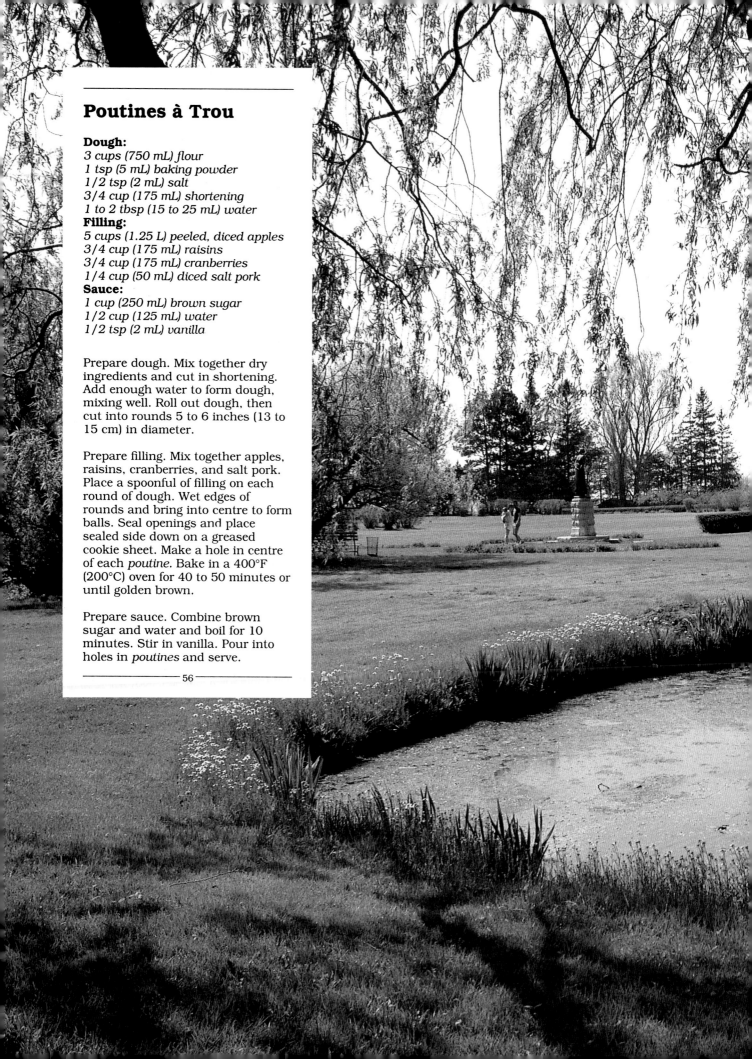

Poutines à Trou

Dough:
3 cups (750 mL) flour
1 tsp (5 mL) baking powder
1/2 tsp (2 mL) salt
3/4 cup (175 mL) shortening
1 to 2 tbsp (15 to 25 mL) water
Filling:
5 cups (1.25 L) peeled, diced apples
3/4 cup (175 mL) raisins
3/4 cup (175 mL) cranberries
1/4 cup (50 mL) diced salt pork
Sauce:
1 cup (250 mL) brown sugar
1/2 cup (125 mL) water
1/2 tsp (2 mL) vanilla

Prepare dough. Mix together dry
ingredients and cut in shortening.
Add enough water to form dough,
mixing well. Roll out dough, then
cut into rounds 5 to 6 inches (13 to
15 cm) in diameter.

Prepare filling. Mix together apples,
raisins, cranberries, and salt pork.
Place a spoonful of filling on each
round of dough. Wet edges of
rounds and bring into centre to form
balls. Seal openings and place
sealed side down on a greased
cookie sheet. Make a hole in centre
of each *poutine*. Bake in a 400°F
(200°C) oven for 40 to 50 minutes or
until golden brown.

Prepare sauce. Combine brown
sugar and water and boil for 10
minutes. Stir in vanilla. Pour into
holes in *poutines* and serve.

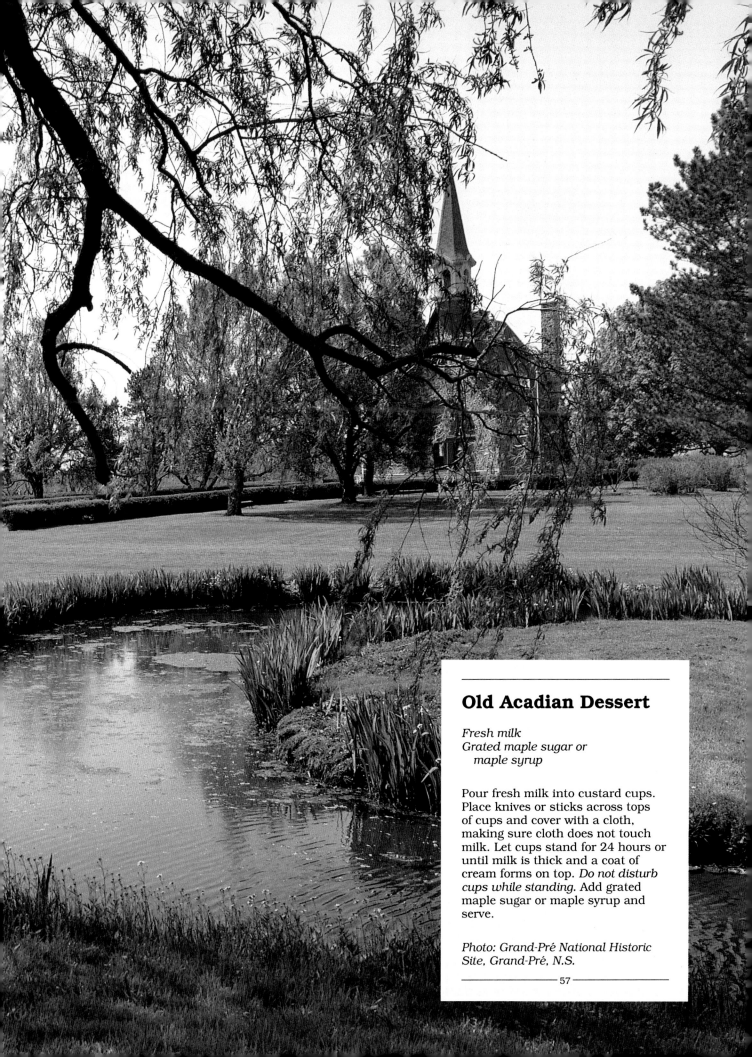

Old Acadian Dessert

Fresh milk
Grated maple sugar or
 maple syrup

Pour fresh milk into custard cups.
Place knives or sticks across tops
of cups and cover with a cloth,
making sure cloth does not touch
milk. Let cups stand for 24 hours or
until milk is thick and a coat of
cream forms on top. *Do not disturb
cups while standing.* Add grated
maple sugar or maple syrup and
serve.

*Photo: Grand-Pré National Historic
Site, Grand-Pré, N.S.*

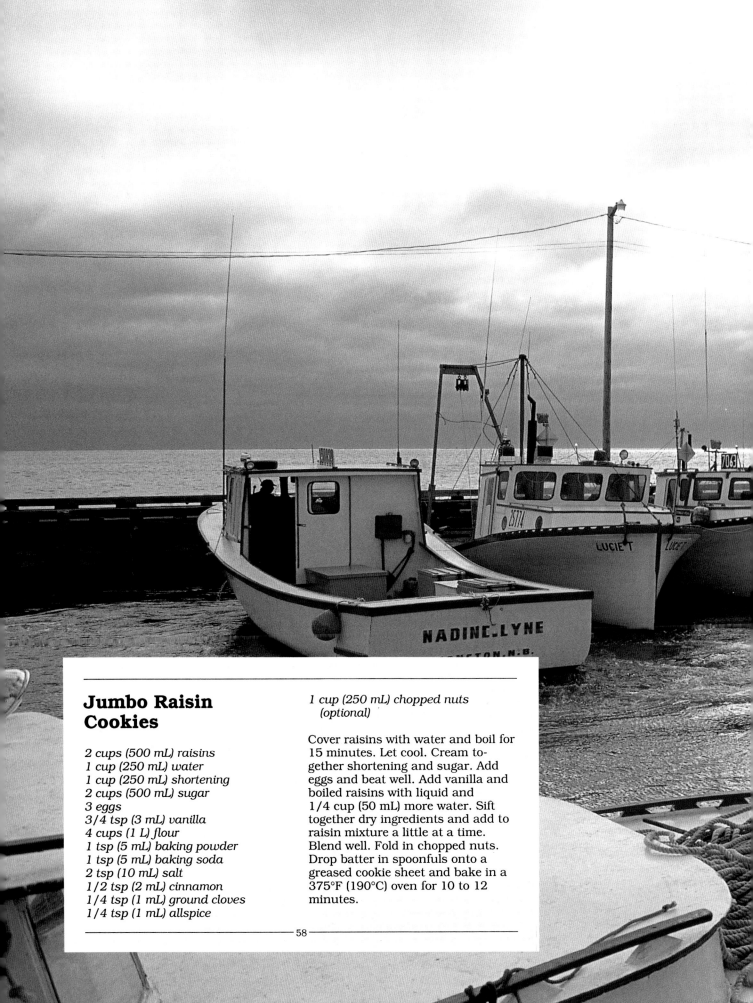

Jumbo Raisin Cookies

2 cups (500 mL) raisins
1 cup (250 mL) water
1 cup (250 mL) shortening
2 cups (500 mL) sugar
3 eggs
3/4 tsp (3 mL) vanilla
4 cups (1 L) flour
1 tsp (5 mL) baking powder
1 tsp (5 mL) baking soda
2 tsp (10 mL) salt
1/2 tsp (2 mL) cinnamon
1/4 tsp (1 mL) ground cloves
1/4 tsp (1 mL) allspice

1 cup (250 mL) chopped nuts
 (optional)

Cover raisins with water and boil for 15 minutes. Let cool. Cream together shortening and sugar. Add eggs and beat well. Add vanilla and boiled raisins with liquid and 1/4 cup (50 mL) more water. Sift together dry ingredients and add to raisin mixture a little at a time. Blend well. Fold in chopped nuts. Drop batter in spoonfuls onto a greased cookie sheet and bake in a 375°F (190°C) oven for 10 to 12 minutes.

Ginger Cookies

1/2 cup (125 mL) shortening
3/4 cup (175 mL) brown sugar
3/4 cup (175 mL) molasses
3 cups (750 mL) flour
2 tsp (10 mL) baking powder
1 tsp (5 mL) salt
1 tsp (5 mL) ginger
1/2 tsp (2 mL) cinnamon
1/2 cup (125 mL) cold water

Cream together shortening, brown sugar, and molasses. Mix together dry ingredients and add to molasses mixture. Gradually add cold water, mixing to make a firm dough. Roll out to 1/4 inch (1 cm) thick. Cut with a cookie cutter and place on a greased cookie sheet. Bake in a 400°F (200°C) oven for 8 to 10 minutes.

Photo: Négouac, N.B.

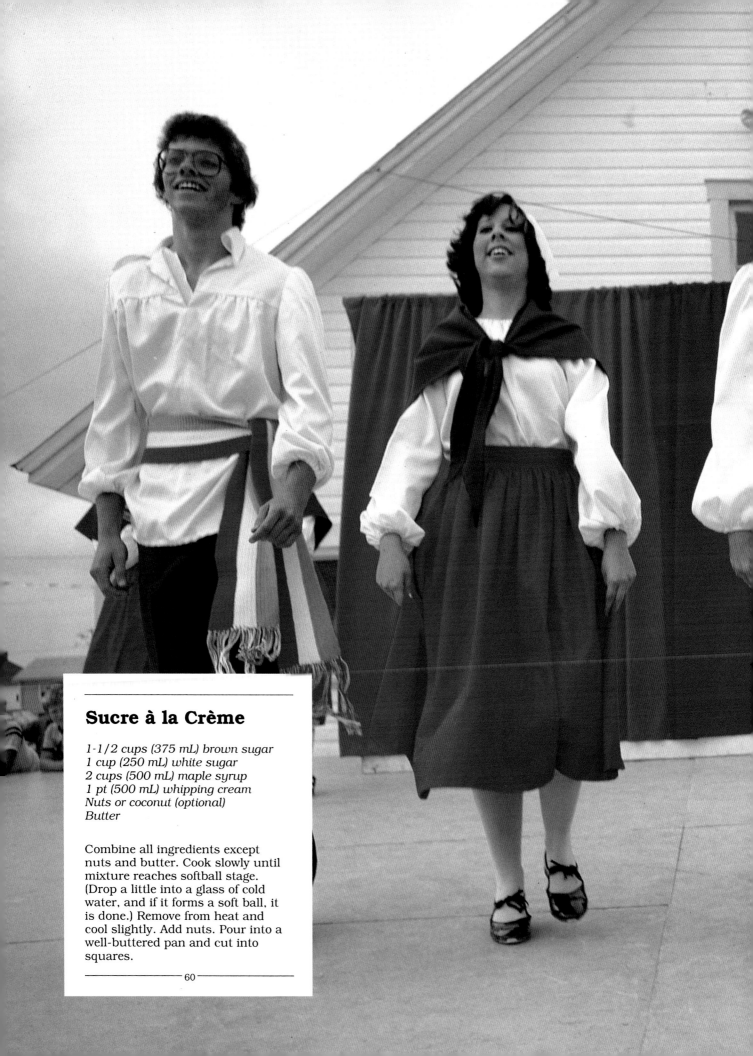

Sucre à la Crème

1-1/2 cups (375 mL) brown sugar
1 cup (250 mL) white sugar
2 cups (500 mL) maple syrup
1 pt (500 mL) whipping cream
Nuts or coconut (optional)
Butter

Combine all ingredients except
nuts and butter. Cook slowly until
mixture reaches softball stage.
(Drop a little into a glass of cold
water, and if it forms a soft ball, it
is done.) Remove from heat and
cool slightly. Add nuts. Pour into a
well-buttered pan and cut into
squares.

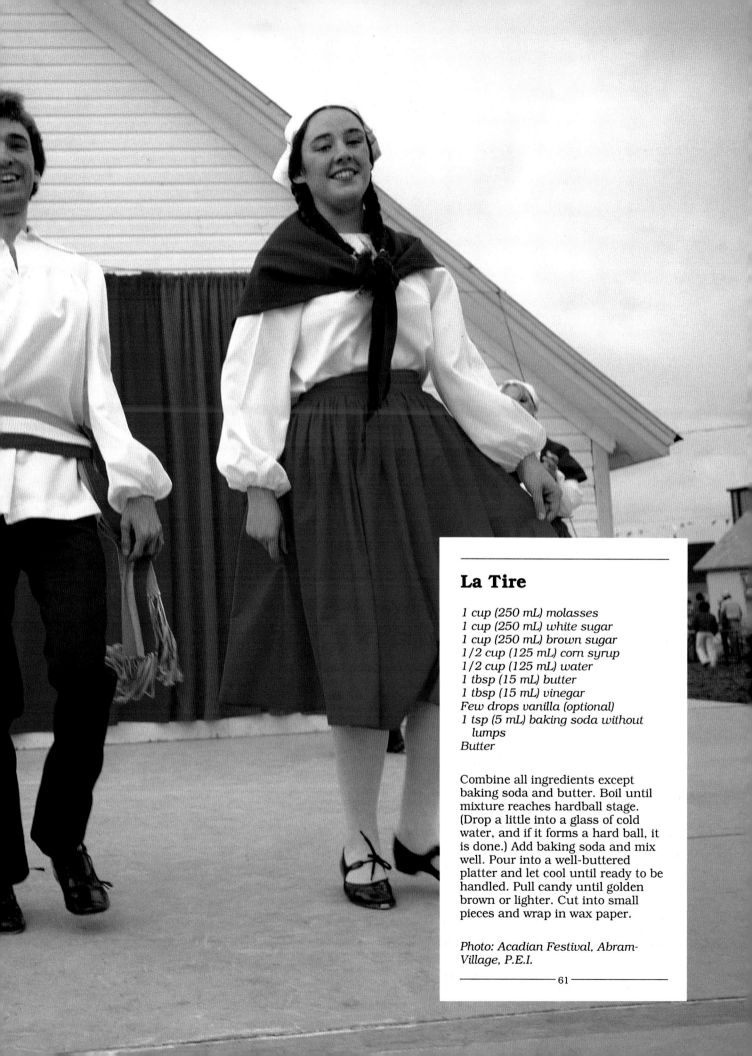

La Tire

1 cup (250 mL) molasses
1 cup (250 mL) white sugar
1 cup (250 mL) brown sugar
1/2 cup (125 mL) corn syrup
1/2 cup (125 mL) water
1 tbsp (15 mL) butter
1 tbsp (15 mL) vinegar
Few drops vanilla (optional)
1 tsp (5 mL) baking soda without
 lumps
Butter

Combine all ingredients except
baking soda and butter. Boil until
mixture reaches hardball stage.
(Drop a little into a glass of cold
water, and if it forms a hard ball, it
is done.) Add baking soda and mix
well. Pour into a well-buttered
platter and let cool until ready to be
handled. Pull candy until golden
brown or lighter. Cut into small
pieces and wrap in wax paper.

Photo: Acadian Festival, Abram-
Village, P.E.I.

Apple Cider

7 lb (3.5 kg) apples
1 gallon (4 L) cold water
3 lb (1.5 kg) sugar

Cut up apples and place in an
earthen crock. Add cold water, cover
with muslin, and let stand for 10
days, stirring daily. When fermenta-
tion has stopped, strain through a
jelly bag. Return juice to crock and
add sugar, stirring until dissolved.
Let stand 7 days, stirring daily.
Skim and pour into a wooden keg.
Cork tightly. Let stand for 6 months.

Left: Wild rose, P.E.I.
Right: Apple blossoms, N.S.

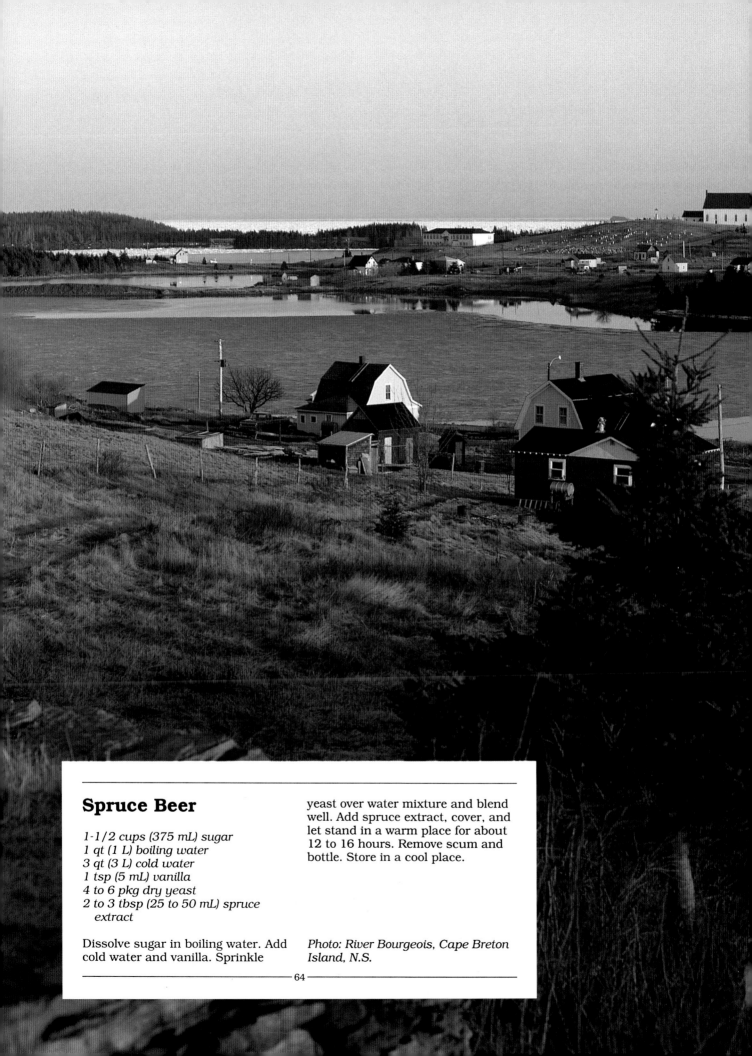

Spruce Beer

1-1/2 cups (375 mL) sugar
1 qt (1 L) boiling water
3 qt (3 L) cold water
1 tsp (5 mL) vanilla
4 to 6 pkg dry yeast
2 to 3 tbsp (25 to 50 mL) spruce
 extract

Dissolve sugar in boiling water. Add cold water and vanilla. Sprinkle yeast over water mixture and blend well. Add spruce extract, cover, and let stand in a warm place for about 12 to 16 hours. Remove scum and bottle. Store in a cool place.

Photo: River Bourgeois, Cape Breton Island, N.S.